Montana's Dimple Knees Sex Scandal

Montana's Dimple Knees Sex Scandal

1960s PROSTITUTION, PAYOFFS & POLITICIANS

John Kuglin

Foreword by Pat Williams

THE
History
PRESS

Published by The History Press
Charleston, SC
www.historypress.com

First published 2018

Manufactured in the United States

ISBN 9781467139182

Library of Congress Control Number: 2018932092

Notice: The information in this book is true and complete to the best of our knowledge. It is offered without guarantee on the part of the author or The History Press. The author and The History Press disclaim all liability in connection with the use of this book.

Dedicated to the people of Butte, America.

All royalties from this book will be paid to the Butte Citizens for Preservation and Revitalization.

CONTENTS

FOREWORD

Home is an interesting word carrying many meanings. For some, the word means their current residence, their street address. Many remember home as the place of their childhood. If you call Butte, Montana, home, your memories are a fortune precious beyond gold.

I do not claim any superiority for those of us from Butte, but I do insist on the specialness of the city itself. Butte is different from other places, distinct, uncommon—it is truly one of a kind. Those who call it home do so with an unusual pride of belonging to a relatively small, lucky group of Americans who live or have lived high against the nation's spine on The Richest Hill on Earth.

Butte, though, is far more than its mining economy and its direct link to the Industrial Revolution. Butte remains a bawdy, boisterous, ethnically diverse city tied into the world of corporate mandates and shift bosses, labor unions and workers, gambling casinos, savvy politics, thinking intellectuals, writers, artists and those simply trying to disappear from society.

I came of age in the tail of the Butte comet, the 1940s and '50s. The earlier, unrestrained Butte, with its 100,000 people, had passed into lore. The city I knew is still one of the West's gambling meccas. Prior to Las Vegas, the city of Butte was wide open—not legally, but literally. The downtown sounds of gambling, gin mills and girls were, in their own way, louder and more memorable than the sounds of screeching metal from the mining operations up on the Hill. However, we noticed with concern the declining number of miners needed to successfully claw at rock to extract the valuable metals.

Pat Williams. *University of Montana, Missoula, Jeanie Thompson.*

Butte is a city of opposites: mansions on one side and shacks on the other, extraordinary riches for a very few and hourly wages for the rest. Unlawfulness crept through Butte's Saturday nights, but the churches were overflowing on Sunday mornings. With this book, author John Kuglin takes a well-researched run at Butte's underside. He reminds us, sometimes painfully, of some of the indiscretions committed by a few of the city's colorful denizens.

It is not only Butte's past but also its ever-present promise that compose its specialness. Make no mistake: those of us who know our hometown fully, if not openly, recognize the old girl's blemishes, but we can't help agreeing with the final four lines of Berton Braley's poem "Butte," written a century ago:

> *Her faults and sins are many*
> *To injure her fair repute,*
> *But her heart and soul are cleanly.*
> *And she's beautiful dear old Butte.*

PAT WILLIAMS

Pat Williams is from Butte. He taught school in the Mining City and served Butte in the Montana Legislature in 1967 and again in 1969. In 1979, he was elected to the U.S. Congress and reelected eight times. Pat returned home in 1997 and for seventeen years taught at the University of Montana–Missoula. He and his wife, Carol, are retired.

ACKNOWLEDGEMENTS

When you write a book, you can't do it by yourself.

My wife, Gale, supported me during this long project, provided valuable advice and understood when I left for yet another trip to Butte.

Our son, Tom, helped me cope with word processing software, provided computer tips and scanned and took photos for the book.

I couldn't have worked with better senior editors at The History Press than acquisitions editor Artie Crisp and project editor Ryan Finn.

Pat Williams held his U.S. House seat longer than anyone in Montana's history and grew up in Butte. He graciously agreed to write the foreword.

Tracy Thornton, news consultant for *The Montana Standard*, cheerfully rummaged through the newspaper's "morgue" numerous times to dig out obscure files and track down and scan photos. There would not be a book without her help.

Many photos in the book were provided by Walter Hinick, *The Standard*'s talented photographer. Other photo help came from *Independent Record* photographer Thom Bridge, Kristen Inbody of the *Great Falls Tribune* and two extremely helpful Montana Historical Society staffers in Kendra Newhall and Delores "Lory" Morrow. Liz Stepro of the Wallace Mining District Museum provided several exceptional photos for the book's epilogue.

David McCumber, regional editor of *The Standard* and *Independent Record*, let me invade his Butte newsroom to rifle though the files that represent the history of Butte.

Frank Adams and Leonard Iwanski spent hours helping me to develop the manuscript. Frank and I covered the statehouse in Helena for the *Tribune* nearly half a century ago. I worked for many years with Len, the Helena broadcast editor with the Associated Press and one of the best writers in the business.

Charles Johnson, dean of the Montana statehouse press corps, suggested thoughtful changes to the manuscript and helped steer me toward a publisher. I first met Chuck when we covered Montana's 1972 Constitutional Convention.

The entire research staff of the Montana Historical Society in Helena was helpful, especially reference historian Jo Ann Stoltz. Wonderful assistance was also received from the Butte–Silver Bow Public Archives, especially archives technician Kim Murphy Kohn, Director Ellen Crain and Assistant Director Nikole Evanovich.

Tyler Miller, regional publisher of *The Standard* and *Independent Record*, gave me permission to use material, along with Jim Strauss, publisher and editor of the *Tribune*; former *Missoulian* editor Sherry Devlin; *Butte Weekly* editor Robin Jordan; and *Billings Gazette* editor Darrell Ehrlich.

Longtime friends Kay and Tom Ellerhoff carefully proofed the manuscript, correcting punctuation, hyphenation, grammar and other violations of the English language.

Dennis Swibold, a University of Montana journalism school professor and author of *The Copper Chorus*, a history of The Anaconda Company's early domination of many Montana newspapers, provided helpful suggestions.

Also helpful in many ways were Dave and Crystal Shors, Ron Waterman, Bob Anez, Evan Barrett and Jerry Holloron, former chief of the Lee Newspapers State Bureau. Others helping include former college classmate Brad Snyder; John Brewer, the AP bureau chief I worked for when I was the AP correspondent in Spokane; former *Havre Daily News* publisher Dwight Tracy and his wife, Mary; and Sidney Armstrong, daughter of Richard O'Malley, author of *Mile High Mile Deep*.

Finally, thanks to the people of Butte—those who fought vice in the 1960s and others who wanted it.

Where else but in Butte can you convince a meter reader to rip up the ticket on your windshield? Or ask a courthouse employee to find and copy documents and then be told, "No charge."

As they say in Butte, "Have a go!"

PROLOGUE

One could almost say Montana rose on the shoulders of Butte, as the town flourished, waned and flourished again, not just once, but several times, always grabbing its bootstraps and reinventing itself, which is why the phrase "Butte, America," was coined. Its pride endures.
—Russell Chatham, artist, writer, book publisher and fly fisherman[1]

I first saw Butte late at night more than half a century ago when I was a young newspaper reporter driving from Colorado to work at the *Missoulian* in Western Montana.

I drove over old Pipestone Pass and descended a few switchbacks on the winding, two-lane highway. In the distance was a fleeting view of the famous mining city. Butte was stunning, glittering with thousands of lights on the west side of the Continental Divide.[2]

Like many cities in Montana and the West, Butte began as a mining camp. Prospectors had some luck panning gold from Silver Bow Creek, named for the sun shimmering off the water. Later, there was profitable lode mining for silver in the mile-high area. Copper was found in modest quantities, with a significant strike in 1876 at the Parrott Mine.

The big payoff came in 1882 at the dawn of the age of electricity when a giant vein of copper was discovered in unheard-of quantities in the Anaconda Mine. By 1896, Butte was helping to electrify America, mining more than 26 percent of the world's copper and justifiably calling itself the "Richest Hill on Earth." Over the following decades, incredible fortunes would be made

from mining the mineralized knob behind Butte and one mile under the city for copper, silver, gold, manganese, zinc, lead and molybdenum.

I stayed overnight at a cheap motel on the edge of town. The next morning, I drove up the hill to see downtown, locally called "Uptown." Butte didn't look as stunning in the daylight. If anything, the city looked a little worn down, but I felt right at home.

Like some areas on Chicago's South Side, where I was born, there were "flats." With few exceptions, they were the only ones in Montana—where separate families lived on different floors in narrow houses on narrow lots.

Like in Chicago, there were the familiar neighborhood bars—an incredible number of them, sometimes two or three in one block and on most corners. Butte still has plenty of flats and no shortage of bars. In 1965, some buildings had no roofs. Boards were nailed across broken windows. Other buildings leaned or were falling down. Mine tailings washed into streets in some hilly sections of the city.

Mining headframes, also called gallows frames, supported cables that transported miners and brought up ore. They were scattered randomly and dominated the skyline of Butte's scarred landscape.

Streets were often named after rocks and minerals: Mercury, Granite, Platinum, Iron, Silver, Quartz, Galena, Porphyry and, of course, Copper.

There were astonishing buildings, including the thin, seven-story Metals Bank, designed in 1906 by famous architect Cass Gilbert, and the M&M Cigar Store, with its Art Deco sign and stainless steel façade.

When I returned to Butte a few months later, I explored the county courthouse, with its heavy copper front doors and tall interior columns. The architectural masterpiece cost nearly as much to build as Montana's capitol building in Helena.

There was the Mother Lode Theatre, the Butte Water Company, the turreted city hall and the fortresslike Hennessy Building, where The Anaconda Company, which owned the mines, ruled Butte from the top floor.

Butte's economy was tied to The Anaconda Company, but it was never a company town. Its residents joked that working for the company meant wearing "the copper collar," but they never actually wore one.[3]

Scattered throughout the rest of Uptown Butte were solid-looking, multistory brick structures. Fires in the 1970s would destroy more than twenty major buildings, but hundreds still stand after more than a century.

I drove by blocks with well-maintained rows of small houses, some painted in outlandish colors, that had once been filled with Cornish, Scandinavian, Chinese, Croatian, Serbian, Italian and Irish mine workers

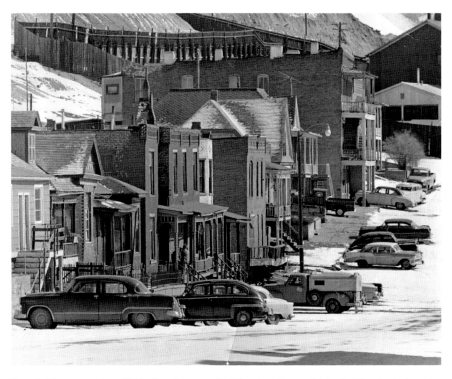

Butte's Finntown, circa 1960, showing crowded flats housing multiple families, including the three-level flat at the end of the street. *Butte–Silver Bow Public Archives, PH512.081.*

and their families. They made the small industrial metropolis the most cosmopolitan city in the region and the largest between Minneapolis, Denver, Salt Lake City and Spokane, Washington.

For many years, thick clouds of sulfurous pollution settled over the city as ore was roasted to extract metals.

Butte's fortunes and population peaked during World War I, when copper prices and production surged. An estimated ninety-three thousand people lived in Butte and its suburbs by 1918, before Butte began a decades-long decline.[4]

Boardinghouses sometimes rented the same bed to three miners working different shifts, so it was difficult to accurately count the city's population.

Its residents still sport license plates beginning with the numeral 1, which the county was awarded in the 1930s when it still had the state's largest population. In 2017, seven Montana counties had more people than Butte–Silver Bow.

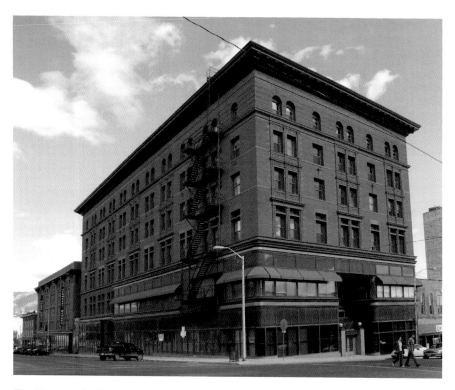

The Hennessy Building, where The Anaconda Company once ruled Butte's economy from the top floor. The basement and first two floors housed the Hennessy Department Store. *Walter Hinick.*

When I first saw Butte, The Anaconda Company was expanding and deepening the Berkeley Pit, the raw, moonlike crater opened in 1955 on the city's east side. The pit had already gobbled the city of Meaderville and blocks of Butte neighborhoods, including Finntown, except for the Helsinki Bar and Steam Baths.

For years, the Helsinki was the center of the observance of St. Urho Day, the day before St. Patrick's Day. While St. Patrick is credited with driving the snakes from Ireland, St. Urho supposedly cast out a plague of frogs from Finland. Later, it was claimed that St. Urho actually saved the Finns from a plague of grasshoppers. In Butte, a St. Urho king and queen are crowned and toasted with purple schnapps.

The Anaconda Company never recovered from the nationalization of its Chuquvicamata Mine in Chile in 1971 and another mine in Mexico; the company's copper production was cut by two-thirds.

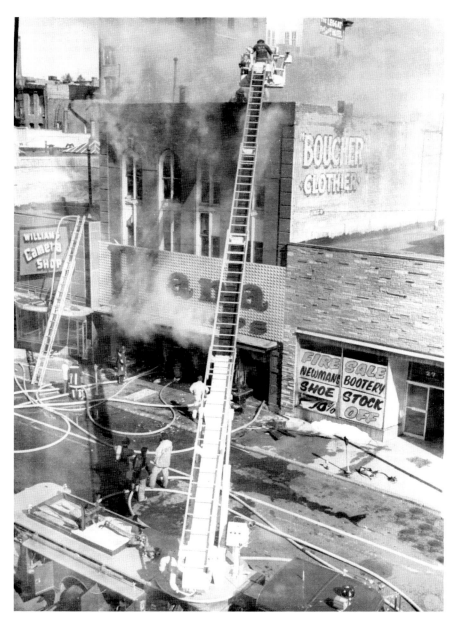

The Diana Hughes store fire, fought in August 1978. The adjacent Newman Bootery was burned out at another location and now advertises a fire sale. From The Montana Standard, *Walter Hinick*.

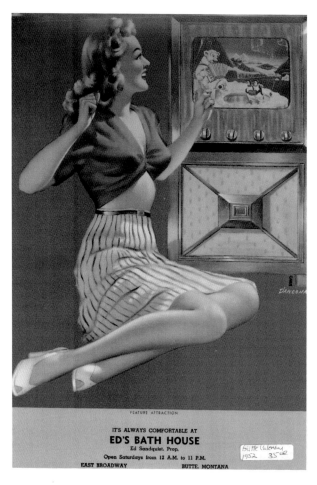

Left: A 1952 pinup calendar for Ed's Bath House in Butte's Finntown, where there were several saunas. Ed's was only open on Saturday. *Crystal and Dave Shors*.

Below: Butte's Berkeley Pit, almost filled with water in 2017, looking east toward the new Continental Pit. *Walter Hinick*.

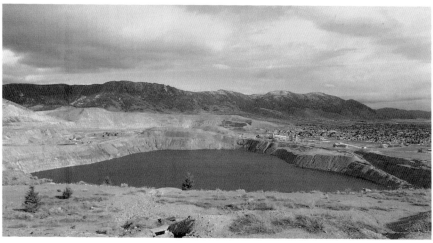

Atlantic Richfield Company took over The Anaconda Company six years later. In 1980, it closed the smelters in Anaconda and Great Falls reduction works. The 506-foot stack at Great Falls was dynamited at a ceremony in 1982. The taller, 585-foot stack at Anaconda still stands defiantly as a state park surrounded by slag heaps. It is 30 feet higher than the Washington Monument.

The company abandoned the Berkeley Pit in 1982, along with pumps worth millions of dollars that were 3,800 feet below the surface in the Kelley Mine and kept water from rising in the pit.

The large hole at the headwaters of the nation's largest Superfund site is steadily filling with colorful but poisonous water. The water from Montana's deepest lake is a hazard to waterfowl but supports fungi, algae and a variety of microbes. Snow geese migrating south have been frequent victims of the pit. In 1995, a flock of the geese made a pit stop in the Berkeley. Later, 342 of them were found floating dead in the toxic water. Thousands of snow geese perished while migrating south in 2016, despite efforts to haze them off the water.

Montana Resources, controlled by Missoula billionaire Dennis Washington, acquired Butte's mining properties in 1986. It has applied for permits to continue to operate the growing Continental Pit east of the abandoned Berkeley until at least 2040. The company plans to divert and treat water in the pit when it reaches a critical level, perhaps in late 2018. The company already treats and reuses some of the surface water draining into the pit in its mining operations.

As the water in Lake Berkeley continued to rise, the Helsinki Bar was briefly called the Helsinki Yacht Club before closing in 2015. The bathtub-shaped hole carved by strip mining is 7,000 feet long, more than a mile wide and 1,780 feet deep. Enterprising Butte markets the nation's largest pit lake as a pay-to-view toxic attraction. It attracts visitors from all over the world.

The first time I looked at Butte, I only saw what was above ground—not the mines as deep as a mile that the Montana Bureau of Mines and Geology says contains an estimated ten thousand miles of abandoned underground workings.

I was a reporter for the *Great Falls Tribune* in 1968 when I went down the Steward Mine to write a story about the installation of nineteen telephones to link levels of the Steward and Mountain Con Mines with the surface.

Ore hauled from the Steward was still producing 5 percent to 6 percent copper. The Berkeley Pit's ore averaged 0.8 percent copper.

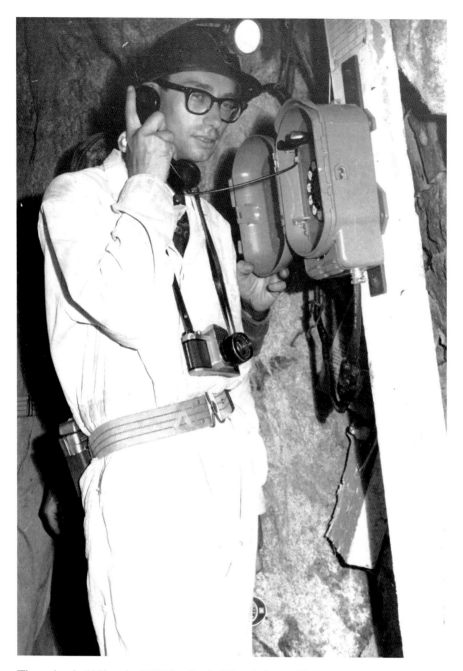

The author in 1968 at the 4,200-foot level of Butte's Steward Mine, where he went to write a story about a new telephone system so miners could contact the surface. *Frank Bell.*

The Steward Mine headframe in Butte. The author went down the mine in 1968. The Finlen Hotel is to the right. *From* The Montana Standard, *Walter Hinick.*

I still remember the feeling of weightlessness, dropping 3,600 feet at 800 feet per minute down a vertical shaft in a "chippy" cage used to transport miners and material (but not ore). I was told to keep my hands and feet inside or I might lose them. It was incredibly hot and felt like walking through a jungle, despite the ventilation system.

As we hiked four thousand feet inside a tunnel used to haul ore, humidity was at almost 100 percent. A member of our group from Butte said it felt like sitting in a sauna at the Helsinki Bar.

Strange blue and green formations grew on the roof and walls of our passageway. Rivulets of brightly colored water ran in trenches near our feet. It was incredibly hot. Our guide said that temperatures of 135 degrees had been recorded below 4,500 feet in Butte's mines. The deepest mine was the Mountain Con at 5,362 feet. Thousands of underground miners worked in these conditions for decades and kept the city's mortuaries busy. The Steward closed in 1973.

Butte is a blue-collar town that experienced decades of labor strikes in its mines, some of them resulting in violence by both labor and management. At times, management brought in Pinkerton detectives to shoot strikers,

The best-known photo of union organizer Frank Little before he was hanged from a railroad trestle in Butte. His killers were never identified. *From* The Montana Standard.

sometimes in the back. Federal troops had to be sent to keep the peace in what some called the "Gibraltar of Unionism."

The Granite Mountain and Speculator Mines fire in 1917 took 168 lives and remains the nation's worst hard rock mining disaster. About 14,500 miners struck Anaconda after the fire, demanding improved safety and better working conditions.

Industrial Workers of the World (IWW) organizer Frank Little was lynched the same year. Six masked men broke into Little's room in a boardinghouse and abducted him in his underwear. He was beaten, dragged tied to the bumper of a Cadillac and hanged from a railroad bridge on the south edge of town.

The inscription on Little's tombstone in a Butte cemetery says that he was "slain by capitalist interests for organizing and inspiring his fellow men." But some believe he was lynched for his antiwar views. No one was charged with his murder.

Nonunion workers operate Butte's remaining open pit mine and receive a bonus when metal prices are high. Butte is still a union town, but it needs the mining jobs. When the underground mines were open, workers finishing their shift might stop for a drink in some of the hundreds of bars. Many miners were partial to the Shawn O'Farrell, a shot of whiskey with a beer chaser.

Others were drawn to the city's red-light district, once one of the largest in the West, where hundreds of prostitutes competed for business. The numerous gambling dens and dance halls were also popular.

Butte was still a raw, wide-open mining camp when I first saw it in the late 1960s, with illegal gambling, about five thriving whorehouses and bars whose owners regarded the state law mandating a 2:00 a.m. closing time as something that only applied to the rest of Montana.

Beverly Snodgrass owned two of Butte's leading houses of prostitution. In 1968, the talkative madam, her affections scorned by an official she called "Dimple Knees" who stole her heart and then her money, decided to tell her story to a newspaper reporter. What happened is the subject of this book.

A VERY SHORT MEETING
WITH THE GOVERNOR

*I swear to my maker that I couldn't have paid the Butte Police Department a
lesser amount than $5,090 in the year of 1961.*
—*Beverly Snodgrass, owner of two of the city's brothels*[5]

It isn't every day that the madam of a house of prostitution blabs
intimate details about her business to a newspaper.

I was a statehouse reporter in Helena, Montana, for the *Great Falls
Tribune* in 1968 when editor Scotty James assigned me to interview the
madam who had operated two brothels in Butte. Beverly Snodgrass said
she contacted other Montana newspapers, including *The Montana Standard*
in her hometown. Only the *Tribune* would touch the story. The *Tribune*
had a reputation for crusading journalism, dating to when The Anaconda
Company dominated Montana's economy, politics and even its newspapers.

Anaconda owned *The Standard* and most of the larger newspapers in
Montana until it sold them in 1959 to Iowa-based Lee Enterprises. Anaconda
did not, however, own the *Tribune*. The *Tribune*, long in private ownership,
was sold in 1965 to the Minneapolis Star and Tribune Company.

I interviewed Snodgrass in the office of Reverend Joseph Finnegan at
Butte's Immaculate Conception Catholic Church, where she felt safe.[6] A
few minutes into the interview, it was clear that she was a madam who knew
too much for her own good. Without prompting from the young priest,
she candidly recalled her torrid love affair with the Butte official she called
"Dimple Knees."

Snodgrass said that her business thrived for several years. Then payoffs to the police and local politicians, including Dimple Knees, "took every cent I had," even with her houses staying open up to eighteen hours a day.

After she objected to paying extortion, the madam said she was severely beaten. An attempt was made in 1964 to use dynamite to knock down a wall of one of her brothels. Her other house was partially gutted by two fires a few days before I interviewed her. The state fire marshal's office called the fires "suspicious."[7]

At this point, Bev ("my friends all call me that") smiled at Finnegan and said she had embraced religion. Bev decided to tell her story to give a boost to Butte anti-vice crusaders, whose leaders included the priest called Father Joe by his parishioners.

As extortion payments increased, the madam hired respected Butte private investigator W.F. Sanders. She gave him copies of affidavits, tape recordings and files detailing how she operated her houses and made payoffs. From her documents, interviews and his own stakeouts for a year, the detective compiled the chilling yet salacious "Snodgrass Report." "The fatal mistake was my falling in love with him [the official], so deeply in love that I told him everything about my business, to the exact figure of money daily that I was taking in, in my business of prostitution," she told the detective.

After the interview in the priest's office, I returned several times to the old mining camp, once checking in for almost a week at a motel in Uptown Butte to interview anti-vice crusaders, cops, politicians and some of Bev's relatives. I also bar-hopped in Uptown Butte so I could write about flagrant illegal gambling and liquor law violations.

After many discussions with my editors in Great Falls and the *Tribune*'s colorful publisher, Bill Cordingley, as well as vetting by the newspaper's corporate attorneys in Minneapolis, the first article in an eight-part series about Butte vice was published on October 13, 1968, on the front page with a banner headline.

The *Tribune*, in what was then Montana's largest city, was the closest thing to a statewide newspaper. Before the series began, Cordingley had "teasers" displayed on the hundreds of *Tribune* news racks around the state, telling people that next Sunday they could start reading a "Butte Expose" about gambling, prostitution and payoffs. "I've waited three years since I became publisher to print a big story like this," Cordingley said.

Cordingley told me that the *Tribune* had to hire another truck during the series to haul 4,500 extra copies a day to Butte, 155 miles from Great Falls. When the series began, the publisher said he went to the *Tribune*'s loading

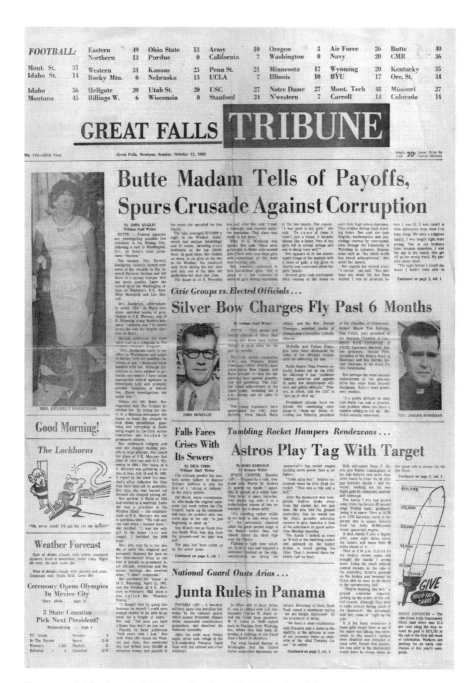

Page one of *The Great Falls Tribune*, October 13, 1968, when it began an eight-part series about Butte vice.

dock late at night to be sure the extra papers, which sold for a dime, had been printed and loaded on the truck for Butte.

On the third day of the series, an article headlined "Butte Madam Describes Love Affair with Politician 'Dimple Knees'" was displayed with extremely large type across all eight columns on top of page one.

That night, I was spending a $100 bonus check from the publisher, buying drinks for friends at a Helena beer bar called the Pub, a hangout for reporters, state employees and students from nearby Carroll College.[8]

As I bought another round, the phone behind the bar rang. "John, are you supposed to be here?" yelled Mike Cloud, the affable bartender. "Some guy says he's calling from the governor's office." I nodded, and Cloud handed me the phone. It was Tom Mooney, who had recently resigned as chief of the Lee Newspapers State Bureau to become executive director of Governor Tim Babcock's reelection campaign.[9]

"The governor wants to see you—now," Mooney said. "At eight at night?" I asked. "Now means now," Mooney insisted. "Tim's waiting for you in his office."

I drove almost two miles to the capitol, wondering what story I'd written that the governor didn't like. The only lights on at the capitol were in the governor's suite on the second floor of the east wing. Mooney was waiting on the ground floor and unlocked a small side door. "What's going on, Tom?" I asked. He didn't reply. I followed Mooney through the cavernous, silent, empty hallway, up a winding flight of granite stairs, through a doorway and into the governor's private office.

Babcock rose from behind his desk. There was no color in his face. "They're going to get you, John," the governor said matter-of-factly. "They're coming over from Butte to kill you....That's all I can tell you. Good luck!"

I found my own way out. As I walked to my car, parked in an unlighted space near the capitol, I thought that hit men—if there were really hit men—probably didn't know much about newspapers. They might think I was writing the series about Butte one story per day. If they killed me, they might think they had eliminated the messenger and the stories would stop. They didn't know that the entire series had already been written, edited and set in lead type. The stories would continue for the next five days. Thousands of *Tribune*s would continue to be hauled every day to Butte no matter what happened to me.

I drove back to the Pub and told Jerry Madden, chief of the Tribune Capitol Bureau, about meeting with the governor.[10] "You should write a story about it," said Madden, exhibiting his black Irish humor. I never did,

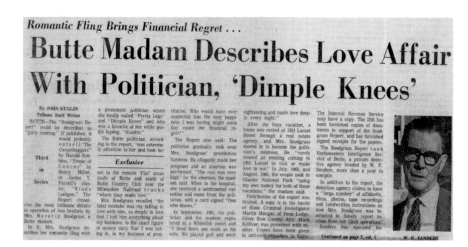

Romantic Fling Brings Financial Regret . . .

Butte Madam Describes Love Affair With Politician, 'Dimple Knees'

Page one of the *Tribune*, October 15, 1968. The photo is of W.F. Sanders, the private investigator hired by Butte madam Beverly Snodgrass.

as I didn't want to be pulled off the story. Like Babcock, Madden wished me good luck. I drove a few blocks to my cramped apartment above a former carriage house in Helena's west side mansion district.

My apartment would be easy for hit men to find because my name and address were in the telephone book. I told myself to calm down as I took the plug out of my twelve-gauge shotgun, a cylindrical piece of wood that prevented waterfowl hunters from loading more than three shells. With the plug out, I loaded the shotgun with five high-powered magnum loads.

Then I remembered that dynamite was sometimes used to settle scores in Butte, including the unsuccessful attempt to damage one of the houses owned by the Butte madam. My bedroom was next to an alley. Would a stick of TNT come through the window?

Two weeks later, nothing had happened. I stopped sharing my bed with a shotgun. But I still slept with the loaded shotgun under my bed. I still look over my shoulder when I'm in Butte.

Chapter 2

INTERVIEW WITH A MADAM

And the whores came. Mercury Street, Galena Street, the Black Cat, the cribs along the street and the girls tapping their knitting needles to get our eye. Two bucks, Jack, come on in. Show you a good time.
—Richard K. O'Malley, Mile High Mile Deep[11]

Bev looked tired as she nervously fingered the lace on her blue-checked dress while I interviewed her in Finnegan's office. She was tall with red hair and appeared to be in her late forties or early fifties. If someone didn't know her former profession, they might have thought she was a parishioner meeting with the priest about something like the fall church bazaar. The former madam proceeded to describe payoffs to local officials and severe beatings when "I didn't cooperate."

Who was Beverly Snodgrass? Beulah Maxine Snodgrass was born in West Virginia and moved to Great Falls, where she waited on tables at Tracy's, a popular downtown diner still open in 2018. She married Maurice Cameron in 1958. They separated three years later and never divorced.

She moved to Butte and worked again as a waitress before she found a higher paying-job at twenty dollars per trick as a prostitute in a brothel at 14 South Wyoming Street in the city's notorious tenderloin district. She later bought the bordello.

Bev said she was popular with customers and had a lot of repeat business from regulars. "We had only one raid when I worked there," she recalled. "I was the only girl in the house that was caught. I forfeited the $300 bond."

Bev purchased 14 South Wyoming from the Andrew Arrigoni estate. Arrigoni had operated the house of prostitution, a few blocks up the street from Butte High School, with his common-law wife, Lee Arrigoni, also known as Ruby Garrett.

The property was sold to Bev at a court-ordered auction two years after Arrigoni, forty, died unexpectedly when Lee, thirty-nine, shot him five times with copper-jacketed bullets, including once in the heart, using a small foreign revolver she had just purchased. Her husband had been seated at a table watching four men play cards in the Board of Trade, a Butte bar. "I didn't plan it, but if he beat me up again I wasn't going to take it anymore," Lee told a prosecutor. Witnesses said that her face was so bruised that they could barely recognize her.[12]

From her jail cell, Lee, who was two months' pregnant, thoughtfully had flowers sent for her late husband's funeral in the small city of Dillon, south of Butte. She was sentenced to four years for manslaughter but served nine months. One of her defense attorneys was James D. Freebourn. He would later become a district judge. "We still think she is innocent," Freebourn told the judge.

After Arrigoni died, it was revealed that he was already married. Lee didn't share in his estate. The wronged common-law wife would buy the Dumas, at 45 East Mercury Street, a famous Butte brothel, twelve years after she ventilated Arrigoni.

Courthouse records show that Bev agreed to pay $16,583—$3,000 in cash and a signed promissory note for the rest of the money—when she bought her first house of prostitution.[13] Bev's first house was once called the Stockholm Hotel, according to a 1917 newspaper account. In later years, it was simply referred to as 14 South Wyoming, or a "female rooming house," a common euphemism for a house of prostitution. Over the years, 14 South Wyoming was regularly mentioned in Butte newspaper columns for murders, stabbings, thefts, assaults, prostitution, robberies and white slavery. A Butte bar owner, Bev's boyfriend at the time, claimed that he gave her money for the down payment on 14 South Wyoming.

At some point, Bev changed lovers and began a long affair with the Butte official she called Dimple Knees. The official had engaged in a fistfight with Bev's ex-boyfriend and beat him severely, Bev said.[14]

Dimple Knees, an attorney, handled the paperwork when she bought the brothel, as well as in 1963, when she expanded her business by buying the Windsor at 9 East Mercury Street, she said.

The smaller brick building to the right at 14 South Wyoming is the first bordello owned by Beverly Snodgrass. A motorcycle policeman is in front of the house. *Butte–Silver Bow Public Archives, Smithers Collection, 30.149.01.*

When Bev complained of being squeezed for higher payoffs, dynamite exploded in February 1964 in the passageway between her brothel at 14 South Wyoming and the much larger Sundberg's plumbing and electrical building. This was apparently an attempt to push in the wall of Bev's house and force the building to be condemned. The explosion only blew a fence and boards into the sidewalk, and the concussion shattered a window.

The private detective hired by Bev said she would have been killed if she had been in the wrong place when the dynamite exploded. No one was charged with setting off the dynamite. The explosion may have inspired Bev to sell 14 South Wyoming, which apparently already had structural problems. "I took a flashlight and crawled under the foundation. That place was ready to fall down," the former madam told me.

Bev signed papers to sell 14 South Wyoming at the end of 1964 to Clare Rogers, one of her employees. Rogers sold the house back to Bev in a deed recorded eight months later. The deed for the last transaction was notarized by Dimple Knees' brother, Bill, also an attorney, as courthouse records show.[15] The property later reverted to a Butte bank and was razed.

"I thought that by going into business for myself I could save enough money to be able to go away in a couple of years," Bev said. "But once you

start a house they won't let you out."[16] By 1967, Bev estimated she had paid more than $75,000 in extortion to stay in the prostitution business.

The take averaged $175 to $200 a night in the Windsor alone, which had antique furnishings and thirty-four rooms, including nine bedrooms on the top (third) floor, Bev said. A large sign near the front door advertised "Free Parking."

The Windsor, which was a little dilapidated when Bev brought it, was known as a "parlor house." Once called the Irish World and then the Missoula Rooms, it had been built and decorated inside lavishly to serve a better class of customer.

In 1908, the Irish World was owned by Ruth Clifford. Warren Davenport, author of *Butte and Montana Under the X-Ray*, described an evening of dancing and excessive eating hosted for Butte's upper crust by Miss Ruth at her "ladies seminary." Even the napkins were of fine linen, delivered from Hennessy's Department Store by a special messenger.

The collared garcons had yellow silk shirts and powdered wigs and wore dress swords. One server tripped on his sword and emptied a bowl of soup down the neck of a Butte alderman. Miss Ruth said the soup cost her one dollar per pint. Mingling with the crowd were twelve young ladies "making their home with Miss Ruth."

Absinthe frappés, crèmes de menthe and Manhattan cocktails were served with each course, and the author said that Miss Ruth, twenty-two, "possesses an abundance of luck and firm determination to carve out a name, fame and fortune."

Sixty years later, when Bev owned the Windsor, Bev said she would admit practically anyone, except teenagers, who came to the door and had the money to pay for sex. "The weirder the request, the more we'd charge. We had a lot of weird requests," the Butte businesswoman said.

Next after parlor houses in Butte's prostitution pecking order were less pretentious bordellos, where furnishings weren't as lavish and the girls were cheaper. At the bargain basement level, earlier in Butte's history, men with fifty cents to spend patronized girls in one-room "cribs." An especially notorious warren of cribs was called "Venus Alley."

The building that housed the Blue Range cribs still stands with doors every few feet opening on Mercury Street. The city directory listed the building as a female rooming house when it was a house of prostitution.

When business was good, Bev said she fielded a line of as many as six girls in the Windsor. She employed only three during the last year. One was on duty when she padlocked her door in 1968 and got out of the prostitution business.

Prostitutes received 60 percent of the money, and the madams got the rest. The madams had to pay off the police and local officials. If a girl had a pimp, he would take most of her share.

When Bev bought 14 South Wyoming, "there were girls right in Butte who wanted jobs," she said. "There were four local girls with reputations at the front door wanting jobs." The madam preferred to hire out-of-town girls. She was proud of what she called a low turnover of about forty-five prostitutes over the years at both houses. "I was good to my girls," she said. "Two of my girls left to attend college, and one is doing very well."

Bev fit the stereotypical image of the madam with a heart of gold. She was a big giver to charity and was concerned about her girls' health. The birthdays of her hardworking employees were usually celebrated with big parties at her houses.

Several of the girls took correspondence courses at the houses to earn high school diplomas, studying during slack morning hours. Bev said that she took college correspondence courses in English, math and psychology. When interviewed, Bev frequently used odd expressions she may have learned from her psychology classes, like "the whole world has moral schizophrenia."

The madam regretted her wicked ways. "Perhaps my whole life has been wasted," she said. "I was an alcoholic before I was twenty-one. I was raised a little differently from what I've been doing. We were a religious family. I was taught right from wrong. Two of my brothers became ministers. I was the one in the family who got off on the wrong track. My parents never knew.... The night before I closed my house [the Windsor] I hadn't been able to sleep. I'll always feel I made the right decision."

Bev, members of her household staff and some of the prostitutes signed notarized affidavits stating that Butte policemen were paid to furnish "protection" and that it was customary to give officers special "presents" at Christmas. "The police would come in and demand my girls, and I'd have to pay them [the girls] out of my own pocket when they were through," Bev said. "The girls didn't like the cops—none of them. It would have been different if they hadn't come in uniform....Maybe you now know why teenagers laugh at Butte cops."

Other houses let in teenagers, but Bev said her places always checked IDs of young men at the door. They had to be twenty-one and match their ID picture to get in the door, she said. "Ask the police. They certainly know."

When threats were made against several of her girls, Bev said she took one of the policemen aside and paid him $100 per night to stay two nights

in the madam's bedroom in the Windsor with her poodles. "He heard me turn down teenagers."

Who were the furtive johns who came to her houses? A mixture of men came to her places, from businessmen to miners, Bev said. "Of course I would never repeat their names. It's not ethical....The Butte guys go to Helena or another town. The guys from out of town come to Butte. I wonder why this is?"

Bev didn't regret her gifts to a Butte orphanage and other charities. "There must be a psychological reason why this made me feel so good," she said, chewing her fingernails during the long interview in Father Finnegan's office. "We were a large family. We never had toys. There were so many things we didn't have."

Bev's hope was that "Butte will become a moral town. More people should help the groups trying to clean up Butte. I paid off for years, but I fought them every inch of the way. They don't like me." Bev also displayed an interest in civic affairs when she ran as a Republican for Butte constable in the June 1968 primary election.

She used her real first name and middle initial, as well as a fictitious surname. Beverly M. Kobe listed her address as 849½ West Quartz. Her sister, Fay Smith, lived at 849 West Quartz, and sometimes Bev stayed with her.[17] Bev was well known in Butte, so she used a messenger to deliver the paperwork and filing fee to the clerk and recorder. Then she told a lot of people, including customers, that she would appreciate their vote.

The madam, the only Republican filing for constable, later wanted to withdraw the Kobe name, but it was too late. The clerk and recorder finally figured out that Kobe was actually Snodgrass, but by then, ballots had been printed. Admirers gave her 463 votes.

Voters gave Bev more votes than nine GOP candidates running for more important GOP nominations, but she didn't run in the general election. Bev never explained why she wanted to be a constable. They mainly serve warrants but can make arrests. Maybe she wanted to try arresting some cops and local officials.

Bev closed the Windsor in June 1968. She was waiting for a prospective buyer a month later when two fires were reported in the house. The July 19 fire partially destroyed the sitting room with the antique mirrors and damaged some furniture. The state fire marshal's office investigated the fires at the vacant Windsor. Firemen responding to the first blaze reported that just before 4:00 a.m. they found the inside engulfed in flames. They extinguished a fire in a sitting room and knocked down embers in a hallway and main staircase.

Two more fires were reported almost twenty-five hours later—one in the basement and the other in the kitchen area on the main floor. The fire in the kitchen left nothing but the sink, Bev said. Files were also rifled in her office. "I guess you could say I quit paying off and they burned me out," Bev said.

Assistant State Fire Marshal Jens Bolstad's report said there was no evidence that an accelerant was used to start the first fire, but "we have reason to believe that something was used to start the fire." In addition to forced entry, an open window and the flame pattern all indicated that the fire had been set.

The fires the next day were "of incendiary nature," Bolstad's report said. "Experience tells us that two fires do not start simultaneously." Bolstad wrote that Butte's fire chief said firemen "detected a strong odor of flammable liquid or gasoline when attacking the blaze and during mop up." "We feel quite certain that the insured [Snodgrass] can be eliminated as a suspect," the report noted. The Windsor was insured for $20,000 and the contents for $6,000. The Windsor was razed in 1970.

Assistant Police Chief Larry Conners said that two men were apprehended at the first fire and said they were about to turn in a fire alarm. The men said they saw two other men climb over a gate.

One month before the fires, Bev told me she had a visit at the house from the bagman who usually collected her payoffs. The bagman, Dimple Knees' brother, Bill, told her that "the old man has put himself out a lot to keep the town open but you have to pitch in and help." The bagman demanded $500. The madam said she might be able to raise $200. He said, "You raise that and more and I'll be back," she said.

When Bill returned a few days later, Bev said that she had planted a tape recorder under a sofa, as suggested by the private detective she hired. The recording was distorted because she was yelling at her poodles during the conversation. Bev said she told the bagman that she still didn't have $500 but would sell two ornate mirrors in the sitting room of her bordello, worth about $1,000 apiece. She had only one girl working upstairs due to pressure from Butte civic groups demanding an end to prostitution.

Bev provided a regular income to cops and Butte officials on the take, including Dimple Knees. It is unlikely they were responsible for the fires or the attempt to dynamite Bev's other house four years earlier.

The insurance settlement from the fires allowed Bev to leave Butte, find a job as a waitress in another state and eventually get a college degree. "You know I'm a pretty good waitress," she said. Bev said she would take

her poodles when she left Butte. "They don't eat when I'm gone and they cry like babies."

Bev's relatives in Butte stayed in touch after she left town, including her sister, Fay, who said, "We have advised her never to return to Butte. They'd kill her." Fay, a cook at a Butte tavern, and her husband, Charles Smith Jr., said the cops harassed them after Bev left Butte. Charles said that prostitution would always be in Butte and should not be closed down.[18]

Before leaving Butte, Bev said she turned over some of her records to the Internal Revenue Service (IRS) and fled in a pickup camper with her seven poodles. Later, Bev said she went to the Washington, D.C., offices of Montana senators Mike Mansfield and Lee Metcalf to tell her story.

After I telephoned Metcalf's office, the senator sent a telegram to my room in a Butte motel, where I was finishing the *Tribune* series that would begin ten days later:

Mrs. Snodgrass came to my office in Washington and asked to discuss with me possible violations of law. I discussed these matters with her. Although jurisdiction in these matters is primarily non-federal I have asked

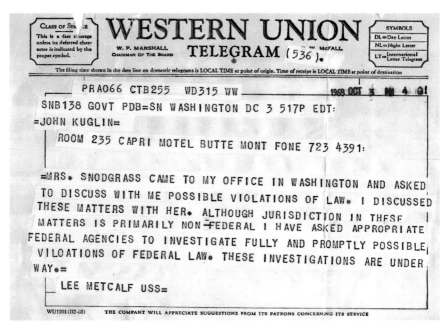

This telegram from U.S. Senator Lee Metcalf to the author at a Butte motel says Metcalf had asked federal agencies to investigate possible violations of federal law in Butte. *From the Great Falls Tribune.*

*appropriate federal agencies to investigate fully and promptly violations of
federal law. These investigations are under way. Lee Metcalf.*

Mansfield, the powerful Senate majority leader, worked eight years in
Butte's underground mines as a "mucker" removing waste rock and later as
a mining engineer. He never confirmed meeting with Snodgrass.

If Mansfield had answered my phone calls to confirm that he had met
with Bev, he probably wouldn't have said anything that I could quote.
Mansfield was one of the few members of Congress without a press
secretary. He didn't need one. The senator would show up at Montana
newspapers without advance notice, often late at night, and usually answer
reporters' questions with "Yep," "Nope" and "Maybe."

Mansfield made one of his nocturnal surprise visits a week after I began
working for the *Missoulian* in 1965. I was in the newsroom on a Sunday night
with Al Himsl, the wire editor. The copy girl had gone home, and the police
reporter was probably in a nearby bar. It was a slow night for news, and Al
had taken out his false teeth.

Someone came in the front door. I had never met Mansfield and didn't
recognize him as he strode toward the copy desk, where Himsl was working
on the front page and I was making up the sports and state news sections.
"That's Mike Mansfield," Himsl whispered as he quickly reinserted his teeth.
"You have to interview him."

The senator's one-word replies to my questions didn't give me much
to work with. Editor Ed Coyle told me it was the shortest interview with
Mansfield the *Missoulian* had ever published.

Chapter 3

DIMPLE KNEES

At one time Dimple Knees was the most famous name in Montana.
—Sam Reynolds, former editorial page editor of the Missoulian[19]

Bev said that her downfall as a successful Butte madam was because of a poor business decision to have a romantic fling with the prominent official she fondly called "Dimple Knees." The madam later began extortion payments to the official, his brother or the police.

One of Bev's Butte relatives gave me a photo of the madam's lover standing in front of a Christmas tree, holding Suzette, Bev's beloved white poodle lapdog. Bev's boyfriend wasn't overdressed for the holidays—just a tank top undershirt, blue boxer shorts with white polka dots and dark stockings held up by garters.

The editors at the *Great Falls Tribune* wouldn't publish the photo. "My God! We have some standards," said Managing Editor Dazz Furlong. But they did print on page one a full-length photo of Bev tastefully attired in a stunning white dress in front of the same yuletide tree.

The lead attorney for the *Minneapolis Star and Tribune*, which owned the *Tribune*, cautioned publisher Bill Cordingley against using Dimple Knees' name or identifying others allegedly receiving payoffs because they hadn't been arrested or charged with a crime.

The decision not to identify Dimple Knees made the entire *Tribune* series a whodunit outside Butte. But just about everyone in tightknit Butte knew whodidit.

The official, according to the Snodgrass Report written by Sanders, the detective hired by Bev, "was extremely attentive to her." He would take her to remote areas of the Flats south of the Butte Country Club, west of the Butte Trap and Skeet Club and the Milwaukee Road railroad tracks, "where they indulged in sexual intercourse."[20] "Who would have ever suspected that the very happiness I was having might someday cause me financial regret?" Bev said.

The official gradually took over the madam's prostitution business and began falsifying tax returns for her to sign. She became pregnant as a result of the trysts. Bev went to two prominent Butte doctors for an abortion and said that "the cost was very high." While recovering from her abortion, Bev said the official sent a sentimental valentine and roses with a card signed "J, one who knows." He remembered to send cards for her birthday, New Year's and, ironically, Mother's Day.

By now, the madam described herself as a "back street woman and mistress." She and Dimple Knees registered at a Whitefish hotel in September 1961, and "I lived there one week as his wife. We played golf and went sightseeing and made love deeply every night."

After the busy vacation, Bev, using the assumed name Maxine Stevens, rented a house through a real estate agent at 1911 Locust Street in Butte. Bev's rented love nest was a modest ranch-style house. The politician and the madam spent three weeks living there before he moved back with his wife. But after her lover moved out, he "rarely missed an evening coming to 1911 Locust to visit or make sexual love to me," Bev said. "I was very much in love with this man and sometimes we had so much fun and laughter," she added.

Madam Beverly Snodgrass in front of a Christmas tree in the love nest she shared with Dimple Knees. *From the* Great Falls Tribune.

38

Bev said she remembered distinctly when her boyfriend "would be lying in bed with me in his shorts," and one of her nephews "would come in and tease him and call him 'Pretty Legs' and 'Dimple Knees.'" She said her lover "did have real pretty legs for a man." Her lapdog poodle loved the politician and would wait each evening for him to come in, pick her up and toss her in the air, the madam said.

Some of the politician's relatives—including his brother, Bill; a sister; and her nephews—would join them at the house on Locust Street, sometimes playing pinochle. They also enjoyed listening to raunchy party records by Rusty Warren, whose naughty hits for Jubilee Records included "Banned in Boston," "Bottoms Up" and "Songs for Sinners."

The irritated *Montana Standard* editor, Bert Gaskill, complained to me about including the address of the love nest on Locust Street in the *Tribune*'s series. Gaskill had recently lived one block down the street on Locust from Bev's rental house. "You have ruined the neighborhood," he complained.[21]

Dimple Knees was married but presented Bev with an engagement ring with a small diamond for her birthday in 1961. He later surprised her with a gold wedding band on Christmas Eve and said that he hoped that someday she could wear it legally.

The happy couple took in Glacier National Park in July 1962 and August 1963, "using my money for both vacations," the madam said. Dimple Knees and Bev did a lot of traveling together. The investigator Sanders later retraced their road trips, visiting motels and hotels where the madam said Dimple Knees had registered them as husband and wife. This included not only the hotel in Whitefish and a lodge in East Glacier Park but also places the couple stayed overnight in the Montana cities of Missoula, Great Falls and Dillon and Idaho Falls, Idaho.

Sanders said that when he and an associate visited the scene of the assignations, they were usually able to find room registration cards signed by Dimple Knees as "Mr. and Mrs." The cards had his real name, Butte address and his car's license plate number.

Some registration clerks remembered the couple, especially after Sanders showed them Bev's photo. The license plate numbers on the registration cards matched a car owned by the official, Sanders said. The detective marveled at what he found, saying, "In most such clandestine operations individuals use aliases and unidentifiable vehicles."

The relationship between Bev and Dimple Knees began to unravel. While drinking in 1963, the madam said she met a man she didn't know. After seeing him three times, she married him in Las Vegas.

Bev said she was drunk when she was married and didn't know what she was doing. After she received the marriage certificate mailed from Nevada, Bev said she sobered up and asked for a divorce. Her new husband, a Butte brick contractor, said he'd give her a divorce if she gave him $10,000 but later said he'd settle for $5,000.

Bev never said if she received a divorce, but when she was hitched in Las Vegas, she was still married to her estranged first husband, making her a bigamist. An attorney later told her that the second marriage was invalid because she was already married.

Dimple Knees was still very much in Bev's life. After the official had been elected to one of the highest offices in the county, he would come through the back door of her house on Mercury Street and have sex with her at least once or twice a week until the middle of 1965, Bev said.

Distribution of the Snodgrass Report was limited. I had a copy and was told that other copies were given to state criminal investigator Martin Mangan, in Deer Lodge; Governor Babcock; Silver Bow County Attorney Mark Sullivan; and anti-vice crusaders in Butte.

It was difficult to find a copy of the report in the late 1960s and early 1970s, but now it is catalogued and in the archives of the Maureen and Mike Mansfield Library at the University of Montana and the Butte–Silver Bow Public Archives.

In addition to the report, Sanders's detective agency claimed to have a "large number" of affidavits, films, photos, tape recordings and handwritten instructions documenting how the politician told Snodgrass she was to falsely report income from her illegal operations.

I interviewed Sanders several times in his cluttered, unpretentious office on the seventh floor of Butte's Metals Bank Building, where he gave me copies of more documents and let me take his photo. The office, with discreet opaque glass on the door, was the sort of digs that Sam Spade or Philip Marlowe would have enjoyed.

Sanders had operated his detective agency for twenty-five years and was highly regarded by the prominent citizens trying to clean up Butte. He was a state-licensed insurance adjuster and belonged to numerous national professional organizations representing the insurance industry and private investigators.

Sam Reynolds of the *Missoulian* wrote a column years later that called Sanders "an honest and courageous investigator." Reynolds wrote that "Butte news people later said that the investigator was himself of dubious repute, though when I was in Butte a very respectable acquaintance, a member of

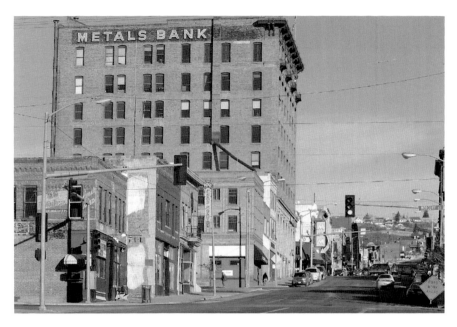

Butte's Metals Bank Building, where W.F. Sanders, the private detective hired by madam Beverly Snodgrass, had an office on the seventh floor. *Walter Hinick.*

the School of Mines faculty, introduced me to the investigator and told me he was a man of stubborn probity."[22]

Bev hired Sanders in 1966. In his report, printed a year later, Bev said she bought the building at 14 South Wyoming in April 1961 "for the sole purpose of prostitution" and was told that payoffs to local officials would be $400 per month. The ante was gradually raised, including a separate $100 monthly payment to Butte police officials as a retainer if one of Bev's customers became unruly. Bev admitted that she received her money's worth from paying the cops. If there was a disturbance at the house, she was to call for police assistance and give each officer $5 or more.

She also gave cash "Christmas presents" to the police. Police celebrated Christmas in 1961 by telling her to buy toys for a Butte orphanage. She had about $150 worth of toys delivered to the house on Locust Street, and they were later given to the orphanage. Bev said that uniformed policemen sometimes acted as bagmen and collected payoffs during the graveyard shift.

When Bev acquired her second house at 9 East Mercury in 1963, the Windsor Block, her total payoffs went to $700 per month for both establishments. Her troubles were just beginning.

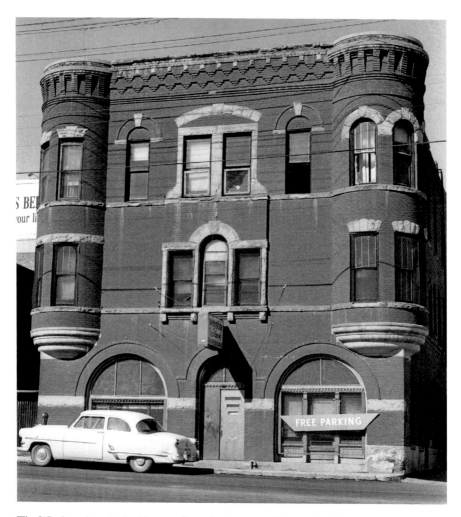

The Windsor, the principal house of prostitution owned by madam Beverly Snodgrass, in 1968. The sign says "Free Parking." *From the* Great Falls Tribune, *John Kuglin.*

"Every time anything happens that I have to call [the police] for help… such as a pimp giving me a bad time.…[T]hat always costs more, a hundred dollars at least," she told Sanders. She had to pay three cops a large amount of money to stay in her brothel on East Mercury for a while in 1963 because a well-known thug and pimp threatened to kill her after two of her girls got into a fight, she said.

Bev and Sanders spent a lot of time trying to prove that Dimple Knees, his brother, cops and some city officials took payoffs from the madam. When Bev went to the law office of Dimple Knees' brother at the Silver Bow

42

Building in 1966 to make one of her regular $700 monthly payoffs—which sometimes were collected at the Windsor—she had a tape recorder in her purse. The tape didn't wind and nothing was recorded.

But Sanders was like a dog that wouldn't give up a good bone. He had Bev give him $700 in cash before she made the next payment. He recorded the serial numbers and chemically marked the bills.

Bev returned to the detective's office in the Metals Bank Building. The detective returned her money in seven packets of mostly twenty-dollar bills. Sanders had impregnated most of the bills with a gelatin fluorescent coating that would glow green under ultraviolet light. When Bev delivered the marked money to Dimple Knees' brother at his law office, she saw the official watching her from a vacant lot.

It was never explained in the Snodgrass Report or to me how Sanders expected to catch the two brothers if they spent the chemically coated bills. Sanders may have thought the money could be traced back to the brothers if it was deposited at local banks where the detective had contacts. "It is my deep regret that there has been no secure method of determining how this money is distributed," Sanders said, as Dimple Knees and his brother continued to accept marked bills from Bev without question.

While Butte citizens were celebrating Christmas in 1966, fifteen policemen showed up for "presents" of cash but were refused, she said. There was petty harassment, Bev said, recalling that in early 1967 she was told by a policeman to pay three five-dollar parking tickets or he would close her remaining house. Sanders was told a few days later that one of the madam's housekeepers left to open a competing bordello east of the Windsor, had taken two of Bev's girls and knew all her customers and could ruin her.

Bev said she had made a $500 loan to one of the girls so she could come back to Butte from California for a job in her brothel. One policeman the madam called a "sex maniac" came to the Windsor in February 1967 and "took on all the girls," she said.

"Though many believe that prostitution in Butte is controlled by some national syndicate, the syndicate is made up purely of local individuals, most of them so-called officials," Sanders's report said. The fact that this extortion is all cash, is not traced and is not subject to state or federal income taxes appears to make it all the more attractive, Sanders said.

As he investigated his client's claims, Sanders began staking out her house on Mercury late at night, watching who came to collect the payoffs. What

happened on the night of January 3, 1967, was typical. Dimple Knees was riding shotgun for his brother, slowly driving his big maroon Pontiac down Mercury Street along most of what was left of cathouse row.

Dimple Knees made seven passes by Bev's brothel. Inside the Windsor, Bill was making the year's first collection from the gross receipts. It was just after the holidays, and Bev said she had to pay Bill, the bagman, $1,000, which was $300 more than the normal monthly payoff.

Sanders and an associate were watching in the shadows nearby as Dimple Knees pulled into an empty lot and was met by his brother. The madam said that Dimple Knees stored his payoffs in the trunk of his Pontiac.

Desperate to implicate Dimple Knees in accepting payoffs, the madam hired Missoula attorney Anthony "Tony" Keast, who had a large criminal defense practice. He was a poor choice.

She gave Keast four tape recordings that she said contained incriminating comments from several Butte officials, including Dimple Knees himself, as they accepted payoffs. She also asked Keast to determine if she could receive benefits after her estranged husband, Maurice Cameron, died, apparently in Arizona.

After no action by Keast, Bev asked him to return her recordings. Keast sent a letter to Bev in July 1968, saying he believed he returned the tapes, but they could have been "negligently lost or misplaced" by his office. Only one of the tapes recorded a conversation in which a Butte attorney acknowledged receiving a $700 monthly payoff from the madam, Keast stated in his letter. In the recording, Bev complained that another madam had to pay only $400 a month to stay in business.

Bev wrote to Keast again in September 1968 from West Virginia, after she left Butte, asking him again to return the tapes and her tape recorder. She wanted to have the tapes when she went to see Mansfield and Metcalf in Washington.[23]

Keast wrote back, again saying he could not return the tapes because he didn't have them. He offered no further explanation.[24] Keast's letter, which Bev mailed to me from West Virginia, accused her of trying to make him a party to fraud and blackmail.

The Montana Supreme Court disbarred Keast in 1972 for "professional misconduct" in a celebrated pimping case in Missoula County involving what prosecutors said was the procurement of fifteen- and sixteen-year-old girls.[25] One of the two men charged in the case claimed that he procured one of the girls for Keast, his defense attorney. One defendant was acquitted. Charges were dropped against the other man.

In 1978, the Montana Supreme Court, in a three-to-two vote, reinstated Keast's law license after receiving numerous testimonials from former clients. In 1989, the court again disbarred Keast—and never reinstated him—after he pleaded guilty in Missoula to a misdemeanor prostitution charge.[26]

Jolonda Sue Scott had hired Keast to help her with a legal problem involving a debt, said County Attorney Robert L. Deschamps III.[27] Keast told Scott that she could make money as a prostitute and had friends who might be interested, Deschamps said. Instead, Scott went to the sheriff's office, which set up a sting at a motel. Keast arrived at the motel room without his friends and offered his client fifty dollars for sex. Sheriff's deputies monitored the meeting with a camera from another room and arrested Keast. The disbarred attorney died in 2004.

Bev said she was frequently beaten and was once struck by a club and injured in Butte's M&M bar. The madam claimed she was severely beaten in May 1967 in her apartment on the second floor of the Windsor by one of the bagmen. Her relatives in Butte said she required medical attention. Her relatives and employees in Bev's house said her bruises and cuts made it apparent she had been beaten.

There were other injuries, sometimes sending her to a doctor or the hospital. They always came when she was behind in her extortion payments, Bev said. The madam said her assailants were usually her former lover, Dimple Knees, and his brother, the bagman who collected most of her payoffs. But Bev admitted to Sanders that she had once "kicked the hell out of" the official when they were together at the house on Locust Street.

Bev said that at times she feared for her life or that Dimple Knees would follow through with his threat to have her committed to the state mental hospital at Warm Springs. Sanders speculated in his report that she might have received some of her injuries when she lost her balance and fell in the Windsor as a result of her admitted longtime alcoholism.

A cab driver said he delivered at least a fifth of gin to Bev at her house every night, the report said. The report noted that a few of her employees, some of them tired of working long hours so she could make payoffs, did their best to keep her drunk. When she passed out, some of them stole her money.

Four exceptionally graphic, notarized affidavits by Windsor employees named Butte cops and city officials for accepting payoffs, sex on demand or both. The affidavits were signed by housekeeper Anna O'Malley, door attendant Kathryn "Kissy" Avery, prostitute Dorothy Maddux and cleaning

woman Dorothy Barker.[28] Ben Hardin, Butte's former police commissioner, notarized the affidavits in April 1967.

O'Malley recalled a $700 payoff to a bagman in March 1964. "I tried to short him but he did not let me get away with it," her affidavit stated.

Avery recalled when a city official, an attorney, visited and demanded five dollars. Instead of giving him the money, she told him, "I was authorized to allow him to stay with one of the girls to the extent of twenty dollars which Beverly Snodgrass would pay her for her services." The official went to a room with one of the girls, Avery said. She said that four policemen would come regularly to the brothel and demand the services of the girls. "They are accommodated and the girls are paid by Beverly Snodgrass for their services."

Maddux's affidavit said that during December 1966 and the next three months, "I have allowed sexual intercourse between myself and three Butte city policemen." She named the policemen and said that Bev paid her twenty dollars for each trick. "If prostitution and gambling were legal in this state there would be no way for these things to happen because money will make good people become cruel," Bev said.

Chapter 4

A LONG NIGHT ON THE TOWN

Butte…still drinks her liquor straight.
—*historical marker along Interstate 15, east of the city*

A night on the town in Butte in 1968 might end only a few hours before the sun rose over the headframes above the mines. There was always a place to get a drink.[29]

The city's remaining brothels appeared to be shut down in early October after several policemen, acting on their own, forced them to close. They didn't have to close the remaining house once operated by Beverly Snodgrass. It had been partially torched almost three months earlier, and she had left town.

I set up an interview with the honest cops who closed the brothels. They later had second thoughts, saying they might be fired if they talked to a newspaper reporter. The officers did tell an anti-vice group that they abated the houses by harassing customers at the front doors and giving the madams a choice between shutting down and jail.[30]

Yvonne McFadden had operated the Victoria at 11 East Mercury Street, next to Bev's Windsor Block. She told me when I knocked on her door that "I closed my place last June, as far as the girls go. Now I got a lot of pensioners living here." McFadden said that several Butte cops stopped at her former brothel four months later to check if the girls were still gone. She said she told the cops she voluntarily closed—"nobody told me to do it."[31]

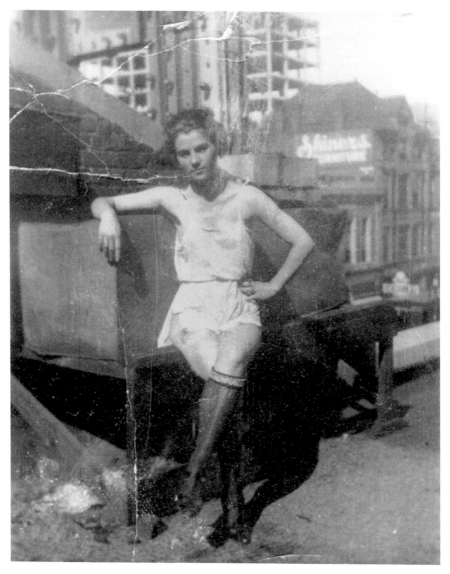

A Butte prostitute on a building roof in 1923. In the background, the Finlen Hotel is under construction. *Butte–Silver Bow Public Archives, PH37.*

The new zeal of some Butte cops to enforce laws didn't extend to wide-open gambling. A roulette-type game called Wheel of Fortune was in the Board of Trade, a crowded card parlor, bar, diner, retail liquor outlet and cigar store. The arrow on the game automatically spun once every sixty seconds around the twelve-number dial. Bettors tried to guess where the

arrow would stop and fed quarters and fifty-cent pieces through twelve numbered slots on the bar. The bartender collected the take and made payoffs after each spin.

"You can bet up to a buck here, more other places," the bartender explained. The game paid 4:1 odds and even odds on dark and light numbers. But the house took all the money if the arrow ended on 9 or 3. This was similar to the "house gets all" for 0 and 00 when playing roulette. The Board of Trade burned to the ground a year later, almost taking out city hall in the same block.

Butte in the late 1960s was no glittering Las Vegas with dozens of casinos, but it may have been the punchboard capital of the world. Punching out the numbers on illegal punchboards was a popular form of recreation in most Butte bars. The devices were boards with holes, each concealing a folded piece of paper with a number. If you had a winning number, you'd get a payoff from the bar. Punchboards were so thick in some bars that you had to rearrange them to set down a drink.

Like most gambling devices, the odds for winning more than you lost to the punchboards were heavily stacked against players, especially if some of the big-paying numbers had already been punched. One argument for punchboards was that they allowed marginal bars to stay open.

A popular punchboard was the "Lucky Sawbuck," which paid $10 on two numbers and lesser amounts on others. It cost only a nickel a punch. The board had 1,500 punches, giving bars $75 for a maximum payout of $43.75.

Punchboards were in all but one of a dozen bars that I visited. A middle-aged woman was happily punching one of six boards on the bar at a tavern when a habitué of the bar circuit arrived. "The boards are going down all over town," he announced. The bartender deftly collected the boards and locked them in a cabinet behind the bar, except for the one being played by the woman. He apparently believed that one punchboard was less illegal than six. To compensate for hiding most of the punchboards, the bartender going off shift bought drinks for the bar. The new bartender bought another round. Half an hour later, the woman was still gamely punching her board.

The punchboards were distributed by a Butte "novelty" company, one of the largest distributors of the devices in the Pacific Northwest, which had large warehouses in the city.

The cops customarily received payola for allowing gambling and extended hours in Butte's bars. A state senator from Butte told me that one way the cops and politicians collected "tips" from bartenders was to ask them to

break a twenty-dollar bill. They would hand the bartender a rolled-up one- or five-dollar bill and get change for twenty.

One of the bartenders said he could keep open after legal hours and have punchboards without interference from the police because "I always take care of the shift commander."

Butte in 1968 had more bars per capita than any city in Montana. In fact, it had more bars than any city in the state—111 including retail beer on premises.[32] The next highest figure was 76 for Great Falls or Billings. Based on the 1960 census, Butte had a population of 27,877, Great Falls 55,357 and Billings 52,851. Butte had one bar for every 251 people, Billings one for every 695 and Great Falls one for every 728.

Despite the city's thriving liquor industry, practically anyone you'd talk to in Uptown Butte, including a state liquor inspector, complained about bars going out of business. A contributing factor was an eight-month strike by Butte miners that ended in 1968.

The liveliest action in Butte was legal. Young couples were on the crowded dance floor at the Rumpus Room in Uptown Butte, which was all that its name implied. The Acoma down the street brought in big-name polka bands.

On the Road writer Jack Kerouac spent a night in Butte in the 1950s. "I walked the sloping streets in super below-zero weather…and saw that everybody was drunk," he wrote. "It was Saturday night and I had hoped the saloons would stay open long enough for me to see them. They never closed," the Beat Generation writer wrote in a story published posthumously.[33] If Kerouac had returned to Butte in 1968, not much would have changed. A lot of the bars didn't close at 2:00 a.m., as state law required.

Several bars in Uptown Butte went through the motions of closing at 2:00 a.m. But they didn't tell drinkers to go home, especially valued regulars, until they had drained their glasses and had one or two for the road. The last drink was often in a "go" cup, which may be responsible for the popular Butte greeting, "Have a go."

As I left one busy saloon, the bartender told me to "Tap 'er Light." This expression, a favorite of Senator Mansfield, had its origin in hard rock mining when dynamite was tamped with light blows into a hole that had just been drilled. If the dynamite was tamped too hard, it might explode, killing the miner and his partner.

At about 2:30 a.m., I noticed that some bartenders followed the tradition of turning off outside neon signs and dimming inside lights. Bartenders continued to diligently pour drinks as long as the crowd was lively.

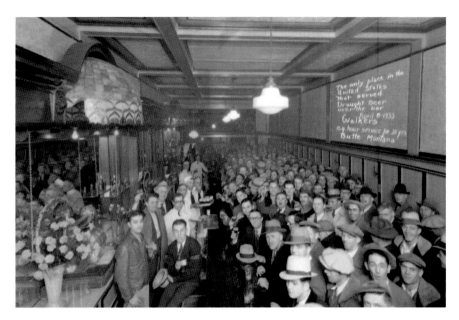

Walker's saloon in Butte is packed on April 8, 1933, after the end of Prohibition a few months earlier. The sign reads, "The only place in the United States that served draft beer over the bar," an apparent reference to Prohibition. *Butte–Silver Bow Public Archives, Smithers Collection, 04.065.04.*

I didn't see any curbies like I saw a few years earlier in Butte while visiting a friend I had worked with at the *Colorado Springs Free Press* (now a reporter for *The Standard*). A curbie was a very informal Butte party that usually began after your favorite bar closed. You sat on the curb, planted your feet in the gutter and passed around a bottle—the local version of mouth-to-mouth resuscitation.

It would take Butte until 2013, during some sort of civic revitalization effort, to kind of adopt an open container law. The controversial law, designed to curb rowdy behavior in Uptown Butte after bars closed, makes it illegal to have an open container of booze on the city's streets, but only between 2:00 a.m. and 8:00 a.m. It is perfectly legal to walk down the street with open containers of liquor or beer during the other eighteen hours. The law was approved by a close seven-to-five majority of Butte–Silver Bow commissioners.

Butte had always justified keeping the bars open after legal hours so miners getting off shift could get a drink. But in late 1968, The Anaconda Company said that only about 550 underground miners were still working in Butte. Fewer than 200 worked the graveyard shift.

Some of the city's retail liquor outlets, especially corner grocery stores, catered to teenagers in 1968, said Father Finnegan. "They just charge the kids another seventy-five cents or so per six-pack for the extra risk," the priest said.

Most of the brothels may have closed, but Finnegan estimated that about eight hookers worked the bars and streets. Another source said the actual number of streetwalkers was closer to twenty-four, and they took their tricks to motels and some of the numerous hotels and rooming houses in Uptown Butte or worked from bars south of the city.[34] The source estimated that the total payoff to local officials and police from gambling, prostitution and liquor law violations was $250,000 per year.[35]

In the mid-1980s, I went into a bar with some Butte friends who got off work about midnight. The dive closed at about 2:00 a.m. Most of my friends went home, but one of them said there was a speakeasy just down the street. I was led to a door in the side of a building. There were no signs, windows or anything else to indicate what was behind the door. The bartender opened a small slot in the door and eyeballed us before allowing us to enter.

The long, narrow, dimly lit after-hours place was packed with customers. Most of the stools were still occupied more than an hour later when we got up to leave. The bartender warmly shook my hand and said he hoped I would come back. I asked why he stayed open so late. "I just like to see people drink," he replied.

A few years later, when I worked for the Associated Press, I took one of my colleagues from Washington, D.C., in town for a newspaper convention to a popular corner bar and diner in Uptown Butte. We had pasties and mashed potatoes drowning in gravy.[36] A pasty is a baked pastry filled with meat and vegetables. They were introduced to Butte by Cornish miners.

My friend noticed that people were coming from a back room and placing bets with the bartender or collecting their winnings. I took him to the back room, where two retainers were industriously posting sports scores and racing results from around the country on a blackboard that covered

The M&M bar's famous Art Deco sign in Uptown Butte. *Walter Hinick.*

most of a wall. A company called SportsTicker supplied the information. AP technicians in the office where I worked in Helena maintained the equipment that printed the scores.

"Isn't it unusual to make book out in the open?" my colleague asked.

"We're in Butte," I told him.

I was once at the lunch counter in the M&M bar with Rick Foote, editor of The *Standard*. I noticed that a man had passed out and managed to wedge himself between the brass rail at the bottom of the bar and the floor. I asked the waiter if someone was going to remove the man. "No, why should we?" he replied.

Chapter 5

BUTTE'S MAYOR SAYS
PEOPLE WANT PROSTITUTION

If prostitution was legalized in Montana, I'd be the first one in line applying for a license.
—Butte's last madam, Ruby Garrett, at age seventy-three[37]

A lot of people in Butte winked at vice. Some of them, including Mayor Tom Powers, even promoted vice. "The people of Butte want prostitution," Powers told me shortly before several policemen, apparently acting on their own, temporarily closed the city's three remaining brothels.[38]

Powers said that padlocking the houses operating in 1968 "would cause more problems than it would solve. You wouldn't know where the girls are. You'd have to chase them down the streets. They would spread out. Mary Magdalene was a prostitute. Every city in the United States over three thousand has prostitutes."

Powers acknowledged receiving complaints that Butte's remaining red-light district was an unwholesome influence because it was only a few blocks from Butte High School and the Vo-Tech School under construction.

The brothels were also close to a World War II memorial—a concrete statue called *Jungle Fighter*, an American GI with a helmet, rifle and full battle gear.[39] A photo from the 1940s or '50s shows Butte High's marching band parading past the infamous house of prostitution at 14 South Wyoming. The brothel, acquired years later by Beverly Snodgrass, is just up the street from the high school.

Butte Mayor Tom Powers (*left*) and mortician Denny Dolan watch a sporting even in Butte in 1968. Powers lost the 1969 municipal election after saying that citizens wanted vice. *From The Montana Standard.*

Butte High's marching band parades past the house of prostitution at 14 South Wyoming Street in the late 1940s or early 1950s. The brothel is the small brick building to the right and was later owned by Beverly Snodgrass. *Butte–Silver Bow Public Archives, PH417.02.*

The *Jungle Fighter* statue first placed in 1944 near Butte High School and the red-light district. The GI has now seized the high ground at the top of the municipal courthouse steps. *Walter Hinick.*

Powers said that he promised Finnegan and the other anti-vice crusaders that he would move the houses by the time schools opened in the fall. Finnegan denied that the groups received this pledge.

Powers boasted that he didn't receive payoffs from illegal activities in Butte and had seven daughters and two sons "who are proud of their father. I've never been in a house of prostitution myself. At least we're honest in Butte and admit we've got houses of prostitution. That's a lot more than they do in other cities in Montana where they have houses."

The mayor supported illegal gambling, including the punchboards found in most Butte bars. "Butte is a depressed area. They [punchboards] help the economy. It's useless to send the police chasing punchboards. They just crop up again," he said.

After the mayor's comments were published in the *Tribune*, Powers told the AP that in keeping with Halloween, "the bogey men are out with hatchets and the *Great Falls Tribune* has added a new feature, comics on the front page."

Police Chief James Clark told a different story, despite signed affidavits from Bev's former employees. Their affidavits said that uniformed cops regularly visited to have free sex with the girls and demand bribes. "There are no houses of prostitution or punchboards in Butte that I know of," said Clark. "Punchboards have never been reported to me by my officers."

I told Clark that roulette-type gambling was operating in a big bar called the Board of Trade and that most of the bars had punchboards. Clark said he would look into it. "I've never been in the place," the chief said. The Board of Trade was only a few buildings down from city hall, where the chief had his office.

The chief said his office would act on all complaints from citizens. Shifting responsibility, Clark said that Powers "is my boss and I follow orders." Sheriff Kenneth "Rock" Cunningham said he "stopped prostitution and gambling in Silver Bow County" outside Butte. "Orders were issued to do this when

I became sheriff." The sheriff said there were no punchboards in the county outside Butte. The sheriff told the author that while his office had twenty-three employees, few were available for law enforcement. Others were assigned to such duties as bailiff, jail matron and jailer.

Contradicting Butte's police chief, Silver Bow County Attorney Mark Sullivan told the author, "There are punchboards all over town." Later, he told the AP that he only said he was *informed* there were punchboards all over Butte, but that was some time ago. He didn't know if the gambling devices were there now.

When I interviewed Sullivan, he blamed the police for the punchboards, saying, "The cops are friendly with the bartenders who have punchboards and warn them when the heat is on. Those cops that tell the bars to get rid of the punches [punchboards] are transferred to another shift."

Sullivan said that his job was to prosecute, not be an investigator and lead independent raids. But he said he would be willing to check out the

Silver Bow County Attorney Mark Sullivan gestures, circa 1968. Sullivan said he didn't have enough staff to call for a grand jury to investigate vice. *From* The Montana Standard.

action, accompanied by a newspaper photographer and either the mayor, the police chief or the sheriff. Nothing came of that or my suggestion that we walk out of his office and simply go down the street to visit a few bars. The county attorney said he had things to do that were more important. I called his office two days later and was told the county attorney was too busy to talk to me.

The county attorney said that Powers was in charge of the police department. He mentioned that the sheriff's office had authority to lead raids in Butte. Sullivan criticized Butte's anti-vice groups for giving the city a "black eye. I'm tired of seeing my name in the newspapers."

Sullivan, later a district judge, dismissed the Snodgrass Report as a personal vendetta. He said the anti-vice crusaders were mostly "do-gooder" Republicans trying to get at Democrats in office. Sullivan, like most Butte office holders, was a Democrat.

Snodgrass had left town. "It would be a heck of a thing if I tried to file charges over this thing and the chief witness wasn't available," Sullivan said.

The prosecutor said he personally conducted several raids a few years earlier to confiscate punchboards. "I'm no longer going to do this. I don't like to be in the position of both witness and prosecutor."

Some Butte aldermen agreed with the mayor that closing the brothels would cause more problems than it would solve. One was Joe D. Armstrong. At a city council meeting, he said that during the administration of Mayor Tim Sullivan, when the houses were closed, "women and girls were not safe on the streets." Alderman Bernard J. Sullivan said at the same meeting that his daughter was chased down Main Street and narrowly escaped her pursuer as the result of closing the houses.

Ben F. Hardin, who chaired the Butte Police Commission under two previous mayors, wrote a letter to Powers that said the police department was corrupt, engaged in extortion and "a monster in the heart of the city. There are those who wear the uniform of a Butte police officer who have or at least practice none of the attributes of an officer. They are a disgrace to the uniform of the city which pays them, no matter how little."[40]

I asked a number of sheriff's deputies and policemen if they would talk on the record about gambling, prostitution and juvenile drinking. Only one deputy would talk—if his name were not used. The deputy said that Butte houses of prostitution welcomed business from teenagers. He knew of at least nine youths who received venereal disease from one prostitute. "Ripley wouldn't believe some of the goings-on in this county," the deputy said. "Did you ever hear of a DWI [driving while intoxicated] on a bicycle?" He said that recently twelve boys, eleven to thirteen years old, were riding on their bicycles while they were drunk. The deputy added that punchboards were the "salvation of a depressed area and Butte is depressed. I guess they're okay."

BUTTE REFORMERS

Every legislature takes a whack at Butte. Butte pays you people of the cow counties the highest price for your beef, hides and grain. Is that not enough? Then why in the devil do you persist in poking your beaks into our affairs when it is none of your damn business?
—*Warren Davenport,* Butte and Montana Beneath the X-Ray, *1908*

Butte has never welcomed reformers and critics, including legislators, especially if they weren't from Butte.

Do-gooders like the Silver Bow Ministerial Association and Moral Betterment League sometimes attracted a following in Butte. So did the Salvation Army's marchers at a time when hundreds of prostitutes toiled in the city's extensive red-light district, gambling flourished and bars never closed. Then Butte would return to sinning.

In 1902, *The Butte Miner* published a "Redlight District" wrapper around a Sunday edition, featuring an artist's rendering of prostitution's temptations and evils. Page one of the same edition reported that Montana's capitol building had been completed, calling it a "magnificent edifice for present and future officials of the Treasure state."

The first of two stories about prostitution in the edition was a vague editorial headlined "Rights and Wrongs of the Redlight."[41] *The Miner* appealed to the "manhood and womanhood of the community to arise in judgment against a local disgrace." The newspaper stopped short of calling for an end to prostitution. Instead, the *Miner* suggested moving

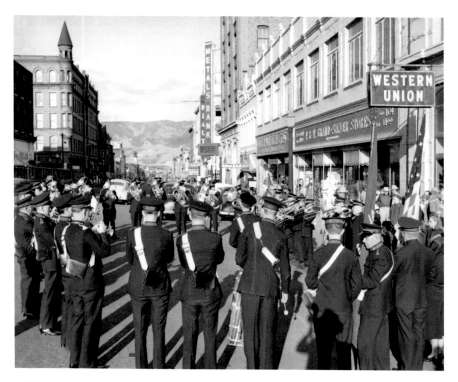

A Salvation Army band plays in Butte in the 1950s. Across the street is a sign that says "Follies." Walker's bar is just up the street. *Butte–Silver Bow Public Archives, Smithers Collection, 2016.173.001.*

the red-light district from the most conspicuous part of the city to an obscure locale.

The newspaper also came to the prostitutes' defense, objecting to a recent city order that required them to keep their window blinds closed. "No human being should be deprived of fresh air and sunlight," the paper said, "no matter how vile her vocation or unworthy her life."

The second story, headlined "Girls of the Redlight," quoted unidentified prostitutes opposed to moving the red-light district. The women couldn't understand how property values were affected by their presence in the middle of Butte.[42] "The sporting women bring a lot of money to the town and they spend freely," one of the prostitutes said.

In 1907, *The Miner* reported that a "ripple of reform" started after a meeting of the ministerial association and "broke with startling force on the city's legislative shore last night, in brilliant flights of oratory and enveloping the entire municipal council like a robe of iridescent purity."[43]

The city council adjourned to tour the red-light district "in all its hideousness." Council members discussed erecting a large gate to close Pleasant Alley, where prostitutes operated from cribs. Another suggestion was to keep prostitutes off the thoroughfares "while plying their nefarious occupations." Nobody talked about shutting down prostitution. Instead, the *Miner* reported, the discussion was about how to "regulate the evil."

The red-light district did close a few times, including during both world wars because the government was concerned that recruits would get VD and be unable to serve their country. The cribs of Pleasant Alley, later called Venus Alley, eventually had gates at both ends and signs telling customers under the age of twenty-one to stay out.

Reformer Carrie Nation was certainly not from Butte. The avenging angel, cloaked in black, arrived in town in 1910, the year before she died. Butte is still talking about her visit.

Carrie had a lot of work to do in Butte, which had 267 saloons.[44] She decided to save the sinners in a whorehouse called the Irish World, whose madam firmly ejected her from the premises. She had another hostile reception at a bar owned by the mayor and soon left town. Butte's swingers had triumphed again over its do-gooders.

Butte reformers in early 1968 included some of Butte's leading citizens and were better organized than Carrie. They attracted large crowds at meetings, including gatherings of the PTA and Junior League.

Six months before the *Tribune*'s series on vice and corruption in the Mining City, two civic groups were at odds with local officials and were getting some ink in *The Standard*. The Civic Action Committee (CAC) and Promote Active Committee Effort (PACE) had plenty of targets, including liquor sales to minors, brothels and the common practice of ignoring the state law that mandated a 2:00 a.m. closing time for bars. Two organizers headed the CAC, John McNellis, a young First Metals Bank officer, and Finnegan.

Butte Mayor Tom Powers criticized the CAC for claiming it had evidence linking extortion and payoffs to some law enforcement officers and public officials. In effect, the mayor told the CAC to put up or shut up.

The Standard would later start complaining about the anti-vice groups after their leaders talked to the *Tribune*. "We think those Butte activists who seek a better moral climate are ill-advised to seek their goal by publicizing, in other sections of Montana, alleged conditions in the Mining City," *The Standard* editorialized, adding, "Further, we believe the moralists are on unsecure ground when they depend upon the apparently unsubstantiated story of a whore, who claims she 'got religion.'"[45]

Left: Father Joseph Finnegan, prominent leader of Butte's anti-vice campaign, in 1968. *From the* Great Falls Tribune, *John Kuglin*.

Below: Butte in about 1965, showing many buildings that later disappeared due to mining and urban renewal. *Butte–Silver Bow Public Archives, PH254*.

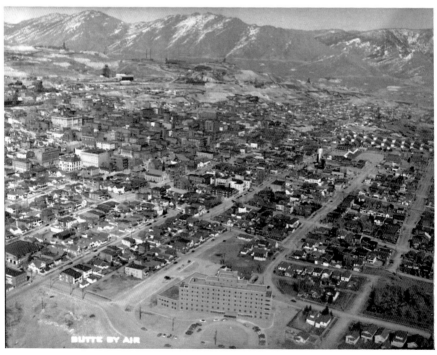

Finnegan's response was, "We had to go to the press. We've tried everything else. Our local officials refuse to enforce the laws."

Later, *The Standard* became more sympathetic toward the reformers and editorialized that citizens shouldn't have to make complaints for officials to enforce laws.

Joe Roberts, president of the Butte Chamber of Commerce, was among citizens involved in the campaign to clean up the city. He owned the dealership that sold the giant dump trucks used to haul ore from the Berkeley Pit. Others included Don Ulrich, owner of an insurance agency and chairman of PACE; Lawrence Mitchell, Jaycees president; Ben Hardin, former chairman of the Butte Police Commission; Joe Shea, chairman of the Silver Bow County Democratic Central Committee; and former mayor Tim Sullivan, who said he closed Butte's brothels during his administration.

McNellis lamented that "as soon as we put the heat on, the punchboards come down for a few nights. A few days later, Butte is wide open again."[46]

Harold Pitts, the respected president of the Miners Bank of Montana, didn't belong to the groups but agreed it was time to clean up the city:[47]

> *Our officials here usually say, "if you want to sign a complaint we'll do something." Why does some citizen have to do their work for them? The law is the law....Most of the people of Butte are wonderful. You can do more business here on a man's word than with a notarized statement somewhere else....We're no longer a mining town. Most of the people in Butte no longer work for The Anaconda Company. We no longer have to be wide open. We don't need prostitution. Butte cannot grow and attract new industry as long as the laws continue be violated.*

The head of the state health department, Dr. John Anderson, decided to jump in, telling Finnegan that it is impossible to control prostitution by confining it to a red-light district where it could be under surveillance. Anderson said the zone would still be a "crime breeding volcano."[48]

Finnegan said it was time for officials to check out the allegations in the Snodgrass Report, compiled by a private detective hired by Butte's most prominent madam and which described the payoffs she made to keep her houses open.[49] "It's in the hands of the attorney general and county attorney. We want to find out if the report is true. We will insist that they investigate all the charges. If they are true, the guilty should be punished," the priest said.

Finnegan added, "I'm not interested in closing bars—though we have as many as three in some blocks. I am interested in respect for the law and in

Banker John McNellis, a leading anti-vice crusader in 1968. He tried to bring more liquor inspectors to Butte. *From the* Great Falls Tribune, *John Kuglin.*

keeping our teenagers out of bars and houses of prostitution."

Finnegan said that other Montana cities had the same problems, "but Butte is willing to face up to the problem with constructive criticism, not ignore them like other cities. We want to make Butte a better place to live in and raise children."

Finnegan, a Butte native, headed the juvenile committee formed the previous year by state District Judge John McClernan. The priest counseled every juvenile the police brought in.

Finnegan was encouraged because "it used to be that out of every six cars full of teenagers stopped by the police, the kids were drinking beer in two of them. Recently the police stopped 25 cars and didn't find any beer. We hear through the grapevine that it's tougher to buy beer if you are underage."

The most unusual endorsement of the anti-vice drive came from Beverly Snodgrass herself, once one of the city's biggest sinners. "It's pretty difficult to deny that Butte has a prostitution problem when you have a madam willing to tell all," McNellis said.[50]

Chapter 7

BUTTE BOOSTERS

I don't like to play cards unless I can cheat.
—Butte motorcycle stuntman Bob "Evel" Knievel[51]

Butte has a slogan: "I'm from Butte, America."
Butte has always had boosters, but three are especially notable. The late Shag Miller owned two radio stations in Butte. He once ordered five thousand "I'm from Butte, America" bumper stickers and ordered thousands more over the years.[52] The Butte Chamber of Commerce also distributed them. Miller was also instrumental in convincing the Montana Highway Commission to extend Interstate 15 south into Butte instead of along an alternate route.

The broadcaster was president of the Montana Association of Broadcasters and the Butte–Silver Bow Chamber of Commerce and, in 1974, had an exclusive live broadcast of Knievel's attempt to jump the Snake River Canyon.

Miller's daughter, Ellen Wendland, said her father's bumper sticker campaign resulted from jokes about Butte during the 1965 Montana legislature's debate over Daylight Savings Time. "It wasn't any kind of promotion for the stations," she said.

The imbroglio in the legislature started when the Senate passed a bill making Mountain Standard Time the state's only legal time. Butte, the tiny city of Walkerville (next to Butte) and Anaconda were the only places in Montana that officially set their clocks for DST.

Broadcaster Shag Miller distributed thousands of "I'm from Butte, America" bumper stickers. *From* The Montana Standard.

The House amended the Senate's bill to say the three cities didn't need to observe Mountain Standard Time.[53] Governor Babcock then vetoed the entire bill, saying it was "discriminatory" against the rest of the state, but not before Butte became the butt of many jokes.[54]

One senator said, "We might as well form a state within a state and call it Butaconda."

The Montana Standard-Butte Daily Post pitched in with an editorial headlined, "'Butaconda' We Are One; That's No Joke."[55] The editorial noted, "It is unfortunate that Butte-Anaconda, the home of the great mining and smelting industries, is so often referred to as 'the only island surrounded by land.' We are painted as being unto ourselves, independent in thought and action. This can only be interpreted as enviable reference."

In 2017, it was difficult to find any "I'm from Butte, America" bumper stickers for sale in the city. Someone may sell them, but the Butte Chamber of Commerce, a large used bookstore and a store selling Butte items didn't have any.

Motorcycle stuntman Evel Knievel, who didn't like to be called a daredevil, was Butte's most famous booster, but he was no reformer. He did have a personal anti-drug campaign and urged motorcyclists to wear helmets.

Bobby—or Bob, as his friends called him—is probably best remembered for his spectacular crash landing in 1967 after jumping 115 feet in his motorcycle over the fountains at Caesars Palace in Las Vegas. When he crashed, Knievel crushed his pelvis and femur; fractured his hip, wrist and both ankles; and had a severe concussion. I described the Butte native in a 1969 profile in the *Tribune's Montana Parade* section as someone whose "career reads like a hospital admittance record."

The public has a distorted idea of safecrackers, Knievel told me, recalling some of his youthful exploits and crimes. Some Butte buildings had fortified doors, so Knievel said the easiest way to break in was to cut a hole in the roof or go through a skylight. "I always got a hell of a feeling about going

through a roof," he said. "It's so quiet inside as you are going down a rope." When cracking a safe, "most people think you kneel down and fiddle with the dial. Hell, you just take a hammer and chisel and go at it. I can open a safe in two minutes."

I encountered Knievel after the profile I wrote about him was published. I was in Butte to write a story about filming of *Evel Knievel*, a movie about his life, starring George Hamilton and Sue Lyon as Knievel's wife, Linda, released in 1971. Knievel recognized me. He didn't look happy. Then he extended his hand. "I liked the article," he said.

In 1974, Knievel tried to soar 1,600 feet over the Snake River Canyon in Idaho on his Skycycle X-2 rocket, but the parachute to slow his descent prematurely opened. His power rig drifted back to the side of the canyon where he was launched. Knievel landed near the river with only minor injuries. This disappointed some spectators. They either wanted to see Knievel complete his jump or die trying. He died in 2007—not on a motorcycle but from pulmonary disease.

In 2001, he told members of the Butte Press Club that despite a youthful crime spree, at least he never robbed the county treasurer's office. But he did

Bob "Evel" Knievel, the Butte motorcycle stuntman who had a reputation as a tough guy, holds a pet poodle in 2002. *From* The Montana Standard, *Walter Hinick.*

The roller coaster at the Columbia Gardens amusement park that William A. Clark built for the people of Butte. *Butte–Silver Bow Public Archives, PH200.*

William Clark, one of the richest men in America, is shown near a log cabin in his later years. He was born in a log cabin in Pennsylvania. *Butte–Silver Bow Public Archives, 47.023.01.*

burglarize a bowling alley and a sports store and spent a weekend trying to break into a bank. He said that now he wanted to publicize Butte and bring money to the town.

Butte's famous son is remembered every year during "Evel Knievel Days." One of the events is a motorcycle procession through town on a route called the Evel Knievel Loop.

There is no Knievel museum in Butte. Most of his memorabilia is scattered around the country, including a large display that includes some of his motorcycles in Topeka, Kansas. The museum includes an "interactive broken bones display."

For sheer boosterism, W.A. Clark, one of Butte's copper kings, couldn't be topped for his comment as president of Montana's 1889 Constitutional Convention. Clark quipped, "I must say that the ladies are very fond of this smoky city as it is sometimes called, as there is enough arsenic there to give them beautiful complexions."[56]

Clark, one of the nation's first billionaires, had his detractors. In 1907, Mark Twain wrote that the tycoon was "as rotten a human being as can be

found under the flag."[57] Referring to the U.S. Senate's refusal to seat Clark for his first term after he bribed Montana legislators to vote for him, Twain wrote, "He is a shame to the American nation and no one has helped to send him to the Senate who did not know that his proper place was in a penitentiary with a ball and chain on his legs."

Chapter 8

LEE NEWSPAPERS LOOK FOR
HANKY-PANKY IN GREAT FALLS

When I worked at The Montana Standard, *there were thousands of underground miners in Butte working in three shifts. I got off work at midnight. All the stores were open, and there were hundreds of people in the streets. It was like the middle of the day.*
—told to the author by Missoulian *editor Ed Coyle in 1966*

In what was clearly the beginning of a newspaper war, the Lee newspapers, irritated by the *Tribune*'s Butte vice series, sent two crackerjack writers undercover to find hanky-panky in Great Falls.[58] In Missoula, Lee's *Missoulian* exposed open gambling, a multimillion-dollar illegal industry. In Helena, Lee's *Independent Record* published an editorial criticizing the people of Butte for being "kind of proud" of illegal activities like gambling, prostitution and allowing bars to stay open after hours, knowing that payoffs were made to officials.

The Standard fought the *Tribune* with editorials, including one headlined, "Why Our Butte?" The Democratic-leaning newspaper also blamed the state's Republican governor for becoming involved in the city's problems.

The Standard editorialized, "We deplore the whinings of a wilting whore which have become a political issue in the Montana gubernatorial race; that Tim Babcock has injected himself in a local problem as part of his vote-seeking."

The Standard noted, "We have not exhausted local means of handling this matter. We have elections coming up. Let the people decide." The newspaper

scolded the *Tribune*, saying that it "has fallen into yellow journalism and smeared Butte."[59]

In another editorial, headlined "We Tolerate It," *The Standard* explained its view of Butte vice, saying, "We have preached and preached that we the citizens of Silver Bow County are responsible for existing circumstances, that permissiveness that is prevalent in so many homes has flowed into our community life."[60] Turning again to the *Tribune*, *The Standard* said that "it bent the time-hallowed guidelines of responsible journalism to make a fast buck."

The *Tribune* ignored *The Standard*'s attacks. Instead, the newspaper's editorial page stuck to election endorsements and continued to write editorials about local issues, including "Deaf-Blind School Expansion," "The West Side Library" and "Welcome Conventioneers!"

Lee state bureau chief Jerry Holloron of Helena and the *Missoulian*'s Sam Reynolds, the best editorial page editor in the state, arrived in Great Falls too late in October to find any action They were able to report—in an article printed by Lee's *Billings Gazette*, the *Missoulian*, *The Standard* and the Helena *Independent Record*—that two brothels "had flourished openly," along with open gambling, until the lid went on earlier that month.[61]

"The heat's on because of this 'Butte Thing,'" a bar and supper club owner told the Lee writers. He said he had operated craps and twenty-one card games in an upstairs room at his place. The "Butte Thing" was the *Tribune*'s series about prostitution, gambling and payoffs to officials in the Mining City.

Holloron and Reynolds did find where prostitution was said to have flourished adjacent to a legitimate beer bar. The three-building complex—beer bar, trailer and prostitutes' cribs—was near a meatpacking plant northeast of the Great Falls city limits.

An elderly, heavyset black bartender was alone in the bar, sleepily watching *Star Trek* on TV, they wrote. Asked if there were any girls, he said, "They've all gone home." Business was now terrible, he said, and his boss, whom he wouldn't identify, closed down prostitution because of the "Butte Thing." He said that the second brothel in the area had been at a "guest ranch" north of Great Falls, which also closed.

Holloron and Reynolds drove by the guest ranch, surrounded by a high fence. They didn't see dudes or horses, only two German shepherd dogs diligently patrolling on the other side of the fence. A man the reporters interviewed said he once called the ranch and asked if they had horses. "We haven't any horses," was the reply. "But we have lots of nice fillies."

The guest ranch catered to white males and the beer bar, supposedly, to black men, the writers reported, because of the many black airmen stationed at nearby Malmstrom Air Force Base. Person after person told the Lee writers that the beer joint and prostitution enterprise flourished so black airmen would have a place to go for female companionship. The black bartender, however, said that most of the prostitutes' customers were white.

Reynolds and Holloron said they observed pinball machines and other machines around Great Falls that were probably illegal if they involved cash payoffs. They didn't report payoffs.

Vice hadn't been allowed to flourish in Great Falls itself, but it was once found in other areas of the county, the Lee writers reported. They also wrote that the community as a whole, including many prominent citizens, wanted gambling and prostitution available—but not so prominent that it tarnished the community's bright image.

Gambling and prostitution in Cascade County did not appear more prevalent than in other Montana communities, Holloron and Reynolds concluded. Cascade county attorney Gene Daly told the Lee writers that he knew of no prostitution at the beer bar enterprise or illegal card games in Great Falls.

But the Lee story didn't do any favors for Daly in his race for state attorney general against Bob Woodahl, the county attorney in adjacent Teton County.

Woodahl told the *Tribune* that in thirty thousand miles of campaigning across the state, he found widespread prostitution and gambling. Woodahl said he had firsthand information of both in Daly's county.

Daly, reached campaigning in Lewistown, told the *Tribune* that he didn't drink alcohol and hadn't sought votes in bars. He said that maybe Woodahl had seen something in Cascade County that he hadn't seen. If Woodahl had firsthand information about offenses in Cascade County, he should report it to him so he could take action, Daly said.

The buck-passing between Daly and Woodahl sounded like the campaign between candidates running for governor as they argued about what was happening in Butte.

The day after the Lee State Bureau story about Great Falls appeared, the *Tribune* responded with a front-page story headlined "City, County Vice at Standstill." *Tribune* reporter Dick Coon quoted from the Lee story and interviewed the local mayor, the police chief, an unidentified "dedicated" gambler and an "unnamed official." Coon said the gambler told him that prostitution and gambling had stopped in the Great Falls area and Cascade County, except for "floating games" that changed locations to

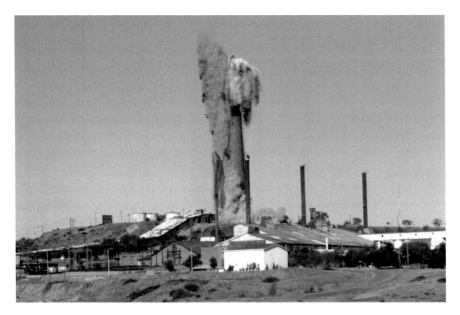

The 555-foot stack near Great Falls, once owned by the Anaconda Company, is demolished with explosives, September 18, 1982, after the reduction works closed. *From the* Great Falls Tribune, *Tom Kotynski.*

avoid raids. There had been no punchboards in the county for years or gambling except for a few illegal pull-tabs in outlying communities, the story said. (Pull-tabs were paper tabs that could be torn open by players to reveal winning numbers.)

The *Billings Gazette* sent reporter Dick Gilluly to Woodahl's county next to Cascade County. He found no prostitution or gambling.

In a sidebar to the story by Reynolds and Holloron, headlined "What About Billings?," the *Gazette* wrote that prostitution was at a long-term low in Billings and that this had nothing to do with the reports out of Butte.

Someone looking for a prostitute in Billings could find one, the newspaper reported, but he'd have to look a lot harder. Today's lady of the evening was likely to be a bar pickup or a call girl, the newspaper said.

The *Gazette, Montana Standard* and other state newspapers mostly limited their coverage of the continuing Butte vice to Associated Press and United Press International rewrites of the *Tribune* series. UPI and the AP also did some original reporting.

In Missoula, there were hundreds of lumber workers in its mills. Like the miners in Butte, they wanted to have a good time after they got off shift. The city had no shortage of gambling but apparently no whorehouses.

My first Montana newspaper job was at the *Missoulian*. This was in the mid-1960s before I left for the *Independent Record* and, later, the *Tribune*. I was hired as a reporter at the *Missoulian* but sometimes took photos, did darkroom work and sat on the copy desk a few nights a week, making up the sports and state news pages.

After the *Missoulian* went to bed at about midnight—if we were lucky— the newsroom crew got off shift. Editors, reporters and printers from the back shop repaired to the venerable Oxford Bar a block down the street. At the Ox, the newsroom made peace with the printers by buying a round for hostile acts like sending them late NBA game stories from the West Coast that had to be squeezed into the trays of type in the composing room. We all drank boilermakers, whiskey in a shot glass dropped in a generous schooner of beer.

At about 12:30 a.m., as the junior member of the staff, I would walk back to the *Missoulian* and get a page one "proof," a smudgy copy of the entire page printed in blue ink. I'd give the page proof to Coyle, who usually joined us at the bar. Sometimes I could also get a proof of the first page of the sports section for sports editor Don Zupan.

Coyle took managing and editing seriously and wouldn't leave his newsroom until the paper was locked up. A perfectionist, Coyle was especially insistent on not going to press without stories about late NBA games. If the printers pressed too hard to go to press, Coyle would run through the newsroom yelling "make over, make over." The printers usually caved. They didn't want to tear apart pages and stop the press to get in late sports stories.

As we sat in the Ox, proofing the paper, we occasionally spotted a serious mistake on the front page. A misspelled word in a headline or the wrong name in a photo caption would qualify. Coyle would then ask bartender T.W. Adams for the phone behind the bar and call the pressroom. If the press had started, Coyle would yell, "Stop the Press!" Then a pressman skilled in deception would take a wooden mallet and artistically whack letters, changing a *Q* to an *O* or making other subtle alterations so readers wouldn't think that illiterates edited their daily newspaper.

Wire editor Al Himsl, who made up the front page and was a genius at editing and page design, would be a few blocks down the street at the Top Hat bar if Coyle needed to talk to him. An enterprising newsboy would come through the Ox and other downtown bars before closing time with a stack of *Missoulians*. We all bought a copy, even though we knew what was in the paper.

The Ox was a combination grill, bar and extensive card parlor. It was always entertaining when someone ordered the house special: brains and eggs. The counter man would yell, "He needs 'em!" The cook would dutifully pour generous portions of beaten eggs and calves' brains with great ceremony on the grill. Other grill choices included an "Inside Job" (liver).

At about 1:50 a.m., while people were still drinking after "last call," T.W. would erect a plywood barricade around the top of the bar to give notice that liquor was no longer officially served. This was just a formality. If someone desperately needed a final drink, especially a regular, T.W. would unofficially hoist it over the barricade and receive unofficial payment the same way.

A few feet from the bar, where Tommy Adams poured honest drinks, were felt-covered card tables. Stakes were often high, and a cashier in a cage at the back of the room exchanged chips for cash and vice versa. No one had to sneak into a back room to gamble.

Gambling wasn't as much fun after Montana legalized games like keno and poker and even started a state lottery after the new 1972 state constitution opened the floodgates for games of chance. The 1889 constitution had prohibited gambling.

The sides of many of the state's bars are now lined with electronic keno and poker machines, and legal poker is played in the open. But stuffing quarters in the gambling machines is about as thrilling as putting money in a washer or dryer in a laundromat, except that you occasionally get some of your money back.

A lot of patrons in the Ox chewed and spit. Overflowing brass spittoons were on the floor in front of the bar and in the card room. Outside the Ox, a small Salvation Army band sometimes arrived to provide free music and song but would also accept donations. With enthusiasm, the band shook tambourines and played drums as they sang "Onward, Christian Soldiers" and other stirring hymns, hoping to save us sinners chugging boilermakers and proofing the *Missoulian*.

Missoulian reporter Les Gapay and I told Coyle one night that we should write a story about the illegal gambling only a few feet from where we were sitting at the bar in the Ox. "Now why would we want to do that?" Coyle asked, ending the conversation. In 1968, the *Missoulian* did just that.

As Reynolds explained in a *Missoulian* column years later, a young law student, Laurence Eck, came into the newsroom and plopped in the *Missoulian*'s lap a fifty-plus-page report about local gambling. This was just before the *Tribune* began its Butte vice series.

Eck had done a thorough job. As Reynolds was leaving Missoula to search for vice in Great Falls, Eck was called in by the *Missoulian* to work on a series exploring illegal gambling in the county.

Eck reported that gambling was a $20-million-per-year industry in Missoula County.[62] Card games were the main source of the illegal money, Eck's series reported, but there was also a lot of wagering on coin-operated games. Despite the state's tough anti-gambling laws, gambling flourished openly "in an atmosphere of official permissive blindness," Eck wrote.

Reynolds wrote that "the public was enthralled. The gamblers were furious. The cops were unhappy. The county attorney's office was upset." Reynolds recalled that "it was the first time that I thought someone might thump me in an alley." Gambling soon resumed in Missoula, and Reynolds wrote that he never had the stomach to ask about Butte and Great Falls prostitution.

As the newspaper war continued in 1968, the *Independent Record* responded to *The Standard*'s editorials against the *Tribune* with an editorial headlined "Butte Likes Its Vice."[63] "Whatever our neighbors over in Butte may be, they're not naïve," the *Record* editorialized. "They know that unlawful activities—whether they be prostitution, gambling or after-hours drinking, whether in Butte or anywhere else—cannot operate openly and flagrantly unless someone in an official capacity is taking a payoff....It's just that in Butte not only don't they care, they're kind of proud of it."

It was to be expected, the Helena paper editorialized, that the county attorney in Butte—although sworn to uphold the law—should bow to the wishes of his constituents and pooh-pooh the whole thing. Asking where was our attorney general, the *Record* suggested he "surely has known that brothels operated openly in Butte and elsewhere in Montana and that the county attorneys in Butte and elsewhere have done nothing about them."

There is organized prostitution in Montana cities besides Butte, the *Record* said, "and let's not kid ourselves, there's organized prostitution in Helena." Indeed there was.

Chapter 9

BUTTE VICE AND THE ELECTION

My choice early in life was to be either a piano player in a whorehouse or a politician. And to tell the truth there's hardly a difference.
—*Harry S Truman*[64]

The "Bev and Dimple Show" quickly became an issue in the 1968 governor's race. Exchanges between the incumbent Republican, Babcock, and his Democratic challenger, Attorney General Forrest Anderson, were especially nasty, even for Montana politics.

Babcock, from his party's conservative wing, operated a trucking business in Eastern Montana when he was elected lieutenant governor in 1962. He became governor after Governor Donald Nutter died on a Montana National Guard plane that crashed with no survivors during a blizzard in Wolf Creek Canyon, between Helena and Great Falls.

Babcock won the governor's race in 1964 and made the mistake of running for the Senate against popular Democratic incumbent Lee Metcalf two years later. He failed to pick off Metcalf, who received 53 percent of the vote.

If nothing else, the Senate campaign was amusing, with the populist Metcalf chiding the governor for engaging in "Babtalk." Metcalf, one of Montana's better senators, championed regulating private utilities. With his aide Vic Reinemer, Metcalf wrote *Overcharge: How Electric Utilities Exploit and Mislead the Public*. Metcalf also supported wilderness protection. After he died in 1978, a national wildlife refuge south of Missoula was named after him, along with the Lee Metcalf Wilderness in southwestern Montana.

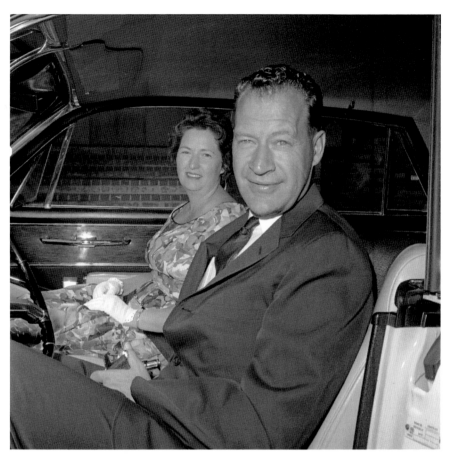

Montana governor Tim Babcock and his wife, Betty, demonstrate correct seatbelt use during a "buckle up" campaign. *Montana Historical Society Research Center Photographic Archives, Montana Highway Department, Chet Dreher, Pac 86-15.631190A.*

Now it was 1968 and Babcock was in a bitter race for his second elected term as governor. He survived a bruising GOP primary in June, challenged by the more liberal Lieutenant Governor Ted James, a Great Falls lawyer. Relations between Babcock and James had been strained after the lieutenant governor appointed a political crony to fill a vacancy on the state Public Service Commission when the governor was out of state.

Anderson, a smooth politician nicknamed the "Silver Fox," was a veteran campaigner and office holder. He was an associate justice of the Montana Supreme Court in 1953–57 and was elected attorney general in 1957. He skillfully needled the thin-skinned Babcock at every opportunity for promoting a 3 percent statewide sales tax, asking "Pay More? What For!"[65]

Left: U.S. Senator Lee Metcalf kept his Senate seat in 1966 when he was challenged by Republican governor Tim Babcock. *From* The Montana Standard.

Below: Montana governor Forrest Anderson announces in 1970 that Big Sky Resort, a major ski area, would be developed north of Yellowstone National Park. *Montana Historical Society Research Center Photographic Archives, Montana Highway Department, Gary Wunderwald, Pac 86-15.70026-4.*

Babcock's campaign had its own slogans, but they weren't especially hard hitting: "Win with Tim," "Montana Forward" and "I Want Tim."

The two candidates for lieutenant governor, including Democrat Tom Judge were also campaigning. Judge ran catchy newspaper ads headlined "Here Comes the Judge."

Anderson and Babcock bombarded likely voters with brochures, pennants, balloons, bumper stickers, yard signs, pins, emery boards and 225,000 matchbooks.

The "Butte Thing" caused unexpected collateral damage late in the campaign for Democrat Daly, the Cascade County attorney, in his campaign for attorney general against the GOP's Woodahl. Daly, the better-known candidate, was left trying to defend his record after the two reporters from the Lee newspapers visited Cascade County and reported that there was prostitution and gambling until recently.

Hoping to pick up votes in Butte, Woodahl placed a large display ad in *The Standard*. The ad said Woodahl was backing Father Finnegan and the other anti-vice crusaders "helping to restore morality in government."

Five months before the *Tribune*'s series, anti-vice crusaders in Butte appealed for help from the governor and attorney general. Members of the Promote Active Community Effort and Civic Action Committee came to Helena on May 16 and met with Babcock.

The groups said they needed state assistance to close the city's brothels, deal with juvenile drinking and call a grand jury, said CAC's McNellis. The groups also asked the governor to sic the state criminal investigator on Butte. Babcock said the investigator worked for the attorney general and that enforcing laws against gambling was Anderson's job.

Babcock did say he would send as many liquor inspectors as possible, just before high school graduation later in May, to enforce laws against underage drinking, McNellis said.

The groups asked Babcock for six liquor inspectors. Two were sent, "whose arrival was heralded," and they showed up in June, McNellis said. The inspectors stayed a week and were responsible for a rash of arrests for liquor violations, McNellis conceded.[66]

Martin Mangan, Anderson's criminal investigator, was given a copy of the Snodgrass Report in July when he went to Butte to talk to the CAC. Seven days later, Finnegan wrote Mangan a certified letter, asking Mangan to investigate crime in Butte because repeated appeals to local officials, including the county attorney, had been met with "intimidating phone calls, pressure on our employers and threats of transfer."

The priest's letter set off a new round of blame shifting. Anderson told Finnegan he had asked Silver Bow County Attorney Mark Sullivan to investigate crime in his area and send him a report.[67] Sullivan replied with a letter to Anderson that said the county attorney had no investigator and needed assistance from Butte police and the sheriff to investigate criminal complaints.[68]

Then Sullivan blamed Finnegan, saying that the priest was the only one who had complained about gambling and prostitution. He said the priest's allegations "were based completely on hearsay reports apparently received from his juvenile parishioners." Sullivan said he told Finnegan he was willing to prosecute violators if he received a proper case.

Sullivan added that he had received a copy of the Snodgrass Report—compiled by the private investigator hired by Butte madam Beverly Snodgrass—which standing by itself "is totally unreliable and without provable foundation."

After several attempts, I finally interviewed Anderson about Butte vice. It was a memorable interview.[69] First the attorney general performed another quickstep, saying that his office would investigate reports of vice in Butte if a request came from the county attorney.

"Our office has to rely on the county attorneys. We do not like to enter into the local officials' problems unless we are asked," he stated. Anderson could have stopped there, but he continued. "Trying to prove a whorehouse is in existence is very difficult." Anderson said he had only one criminal investigator, and Montana, unlike some other states, had no state police.

"We get letters from Father Finnegans all the time," and from the other fifty-five Montana counties, the attorney general added. "A gal came to me and gave me an earful when I was campaigning in Plentywood. Everybody gripes about their local officials….I could fill a truck with this sort of thing. I could give you a bundle that could fill a hayshed. I have a file on bankers that would shock the Montana public."

Anderson said he had asked the IRS to provide a copy of tape recordings that Beverly Snodgrass said she gave to the agency. "They said there were no recordings, but the Internal Revenue Service wouldn't tell you, anyway, if they did have them," Anderson said.

The Silver Fox recalled what former state District Judge Anton J. Horsky of Helena once told him: "Gambling is like a sponge. You push on it and it comes out somewhere else."

In a "Why Our Butte?" editorial, complaining that Babcock was making the city's problems a campaign issue, *The Standard* noted that Anderson "said

he receives complaints from Montana's 55 other counties. Why does not the governor call for grand juries in the Republican counties instead of this Democratic bastion?" Clearly, the attorney general was going to let Butte solve its own problems.

State District Judge James Freebourn of Butte surprised everyone by telling UPI he was considering calling a grand jury. Freebourn said he hadn't yet talked to his fellow judge on the district's bench, John McClernan, but he planned to as soon as the other jurist had disposed of some court matters in the city of Anaconda. Freebourn said there had to be some basis for calling a grand jury, but nobody had talked to him about this.

McClernan said he would like to be left out because the situation was touchy and he didn't care to make a statement about a question that wasn't before the court.

By now, the two candidates for governor were following the Montana political practice of sending letters attacking each other while providing copies at the same time to the news media. Babcock responded to Anderson's interview with the *Tribune*, saying the attorney general had supervisory control over county attorneys and should direct the Silver Bow County Attorney to ask the district court to convene a grand jury.[70] The attorney general said he would be pleased to cooperate with the district court if it wanted to call a grand jury.

Anderson, looking tanned and fit on the campaign trail, said he was anxious to clear up questions about the honesty of Butte and Silver Bow County officials. He was also anxious to "prevent the kind of slander which results from ill-advised and unfounded prosecution, or from political maneuvering."[71]

James Patten, Babcock's administrative assistant, came to the defense of his boss, saying that the 1889 Montana Constitution gave county attorneys the right to prosecute houses of prostitution. The attorney general also had authority, under the state constitution, common law and statutes, to abate nuisance buildings used as brothels, Patten said.[72]

"It would be different if Montana was like some states where the attorney general is appointed by the governor," Babcock told the author. "If that were the case in Montana, I can assure you we'd get some action in Butte."

UPI's Bill McFarland wrote that "incredible as it appears at first blush," Bev and her lover, Dimple Knees, had moved four-square into the center of the governor's race.[73]

McFarland wrote that members of the hierarchy of both parties said that the former Butte madam's exposé of alleged vice and corruption in Butte

"may have a telling effect on the election," but he'd give the advantage to Babcock. "Anderson could still make a bold move, but he probably won't, because Democrats are involved," McFarland said.

This prediction didn't agree with the latest Montana poll for Lee newspapers, released the same day as McFarland's news analysis. It showed fewer voters thought they would "Win with Tim." Babcock was fading fast, the poll showed, trailing Anderson 38 percent to 52 percent. The poll gave New Reform Party candidate Wayne Montgomery 9 percent of the vote.[74]

Late in the campaign, I interviewed Montana political legend Burton K. Wheeler. The Democrat served four terms in the U.S. Senate and fought Franklin D. Roosevelt over the president's plan to "pack" the U.S. Supreme Court with more justices. FDR hoped this would allow him to get favorable rulings for his New Deal policies. The attempt failed.[75]

The patriarch of Montana politics knew all about Butte, where he told me he was fleeced in a poker game in 1905 when he arrived to practice law. Wheeler broke with his party to endorse Babcock's unsuccessful run against Metcalf two years earlier.

I sought out Wheeler, eighty-six, at his rustic cabin on Lake McDonald in Glacier National Park. As Wheeler sat on a rock watching feeding trout dimple the surface of the lake, he said that both Babcock and Anderson were too cozy with big business and he wouldn't endorse either one. "I don't think it makes very much difference who is governor," added Wheeler, who was still practicing law in Washington, D.C. "I'm not taking part in the present race. I've been away from the state too long to know what's going on. I don't know if people care for my views," he added.

Wheeler said he favored Babcock in 1966 to "let the world know that our distinguished Senator Mike Mansfield is not the only senator from Montana."

Former Montana senator Burton K. Wheeler during a 1968 interview in Glacier National Park. Wheeler, a Democrat, did not endorse a candidate for governor. *From the* Great Falls Tribune, *John Kuglin.*

The *Tribune's* series was in its sixth day when I went back to Butte, where Babcock was campaigning in hostile territory. Because of the death threat passed on to me three days earlier by the governor, I wasn't anxious to go to Butte. But one of Babcock's top aides said the governor would march to the courthouse and petition the two district judges to impanel a grand jury.[76]

Two armed state troopers, including one driving Babcock in his black Lincoln Continental limousine, accompanied the governor to Butte. They sternly guarded the doors of a meeting room in a motel on the edge of the city as Babcock blamed Anderson for Butte's problems.

The governor told the county Republican group that Anderson was a "political opportunist. I know you've had some problems recently in Butte. If Forrest Anderson was the great administrator he says he is he would have done something about this."

Babcock wasn't going to do anything, either. He never went near the courthouse when he was in Butte. And the two district judges never called a grand jury on their own. If Babcock had asked for a grand jury, it might have given his failing campaign a boost. But it's likely that Butte vice was only a colorful sideshow in the governor's race. Babcock and the Republican Party had simply miscalculated the public's hatred of a general sales tax.

Appearing optimistic—one of the governor's traits—and surrounded by other Republican candidates for local and statewide office, Babcock said, "Maybe I can come to Butte someday and we'll be in the majority. This could be a two-party town."

Butte, where GOP candidates usually lost by huge margins, was full of Republicans in town for the party meetings. A banner across Granite Street near *The Standard* proclaimed, "1968 Is a Republican Year."

Some of the Republicans became excited when a sound truck drove through Uptown Butte playing "Happy Days Are Here Again." But the song was only announcing homecoming at Montana Tech and had been popularized by FDR when he was promoting his New Deal during the Great Depression.

I filed a brief story to my newspaper, but *Tribune* state editor Tom Kerin spiked it. "There isn't any news," he said. "Why did you go to Butte?" That was a good question.

Chapter 10

BUTTE AFTER
BEVERLY SNODGRASS

I'm more interested in a beautiful citizen than a beautiful city.
—former Butte mayor Mike Micone[77]

Butte was never the same after Beverly Snodgrass. The city didn't exactly experience a reformation after the former madam went public. But its voters gave Mayor Powers, who said people wanted prostitution and gambling, a big heave-ho in the next municipal election.

Nothing happened after Senator Metcalf said he asked federal agencies to investigate the madam's allegations of payoffs to stay in business. The FBI and IRS were silent after Bev claimed that she and the detective agency she hired gave both agencies records and tape recordings to prove her allegations of payoffs to public officials and police to keep her brothels open.

It was only a few weeks after the 1968 general election that prostitution was reported back in Silver Bow County and punchboards returned to Butte's bars. "I can take you to a place just south of Butte and show you the biggest whorehouse in Montana," sighed anti-vice crusader Joe Roberts, nicknamed "Mr. Butte" for his civic endeavors.[78]

Democratic attorney general Forrest Anderson shellacked Republican governor Babcock in the 1968 governor's race with 54 percent of the statewide vote. Babcock had 42 percent, and New Reform Party candidate Wayne Montgomery struggled to get 4 percent.

Babcock had pressed Anderson to clean up Butte but did even worse in Silver Bow County, where he received only 4,978 votes. This was 27 percent

of the vote, 5 percentage points worse than his 1964 showing. I encountered the governor the morning after he lost the governor's race as he showed up at the capitol at the usual time. "Hi, John," he said like nothing had happened.

Anderson, who let it be known that he had no interest whatsoever in sanitizing Butte, received 13,545 votes in Silver Bow, while Montgomery collected 840. Anderson served only one term because of poor health. He is remembered as one of Montana's strongest and best governors for pushing his "executive reorganization" plan, combining nearly two hundred state agencies, bureaus and boards into nineteen departments. He strongly supported calling a convention to rewrite Montana's 1889 constitution. The constitutional convention met in 1972, and the forward-looking document was narrowly ratified by the voters the same year.

I had a major run-in with Anderson over a photo on the back of the 1971 state highway map when I was writing a weekly outdoor column for the *Tribune*. The map photo showed the governor, an accomplished hunter and angler, wading in the Missouri River with his fly rod and a large rainbow trout half hanging out of a small fishing net. The photo was also used in promotional ads placed nationwide by the state, including one in *Outdoor Life* magazine.

The trout pictured on the highway map looked pretty stiff. The governor had also netted the wrong end of the fish, the tail, which would have allowed it to easily jump back in the river. After talking to a few sources in the highway agency, I featured the governor in my outdoor column, reporting that the "net busting" fish reportedly was frozen and transported to the river for the fake photo.

The frozen fish story enraged the governor, who didn't speak to me for weeks. Anderson maintained that he had just caught the trout, which reportedly weighed four and a half pounds, but finally admitted it had been in a freezer before the photo shoot. After Anderson began talking to me again, he said, "Kuglin, I can catch ten fish to your one." I challenged the governor to a fishing contest on the Missouri in late January, writing that the midge fly hatch should be at its peak. Anderson replied, "If it is 14 degrees below zero you won't catch the old man out fishing in the Missouri River."

Underneath the signature on his letter was, "The governor who by his own choice decided not to be governor again, but nonetheless continues to be one of the great fishermen of the era." He copied in AP, UPI and the Lee Newspapers State Bureau.

Dan Bailey, who ran a famous trout shop and fishing fly factory in Livingston not far from the Yellowstone River, later gave me a large fly,

Governor Anderson fishing in
Wolf Creek Canyon near Helena.
Robert Henkel photo

Welcome to Montana

Montana is a land of great variety and
presents the visitor a panorama of the best of
nature's design. The contrasts are beguiling.
From the silent prairies and mountains to the
crash and roar of the mining industry,
Montana, we believe, is an unforgettable
experience.

We hope you will appreciate the beauty and
solitude of our land, and enjoy fishing our
streams, hunting our fields and timberlands,
skiing our slopes, playing our golf courses and
boating on our lakes, and we urge you to see
our museums, hell-bent-for-leather rodeos,
real Indian celebrations, summer theatres,
local fairs and unique shops.

The best thing about Montana is the people.
They are as open and friendly as the country
and are ready to do all they can to make
your visit pleasant.

Montana is more than a state of the union—
it is a state of mind. Enjoy yourself.

Governor of Montana

Governor Forrest H. Anderson wading in the Missouri River and netting a stiff trout that
had been stored in a freezer. This photo is from the back of the 1971 Montana highway
map. *Montana Historical Society.*

shaped like a curvaceous mermaid and covered with spangles, to present to
Anderson. The governor had the fly displayed in the bar at the small town
of Craig near his fishing cabin. We got along better after that.

Health problems continued for Anderson after he left office. He committed
suicide in 1989 by shooting himself at the age of seventy-six.

After his defeat, Babcock was hired as executive vice-president of a
subsidiary of Occidental Petroleum in Washington, D.C., headed by
Armand Hammer. Babcock pleaded guilty in 1974 to concealing Hammer

as the source of $54,000 he illegally funneled to Richard Nixon's Committee to Re-Elect the President ("CREEP"). A federal judge fined the former governor $1,000. A four-month prison term was later set aside by the judge, who called Babcock a "leg man," after another federal judge only fined and put the aging Hammer on probation instead of sending him to jail.

Babcock returned to Montana and dabbled in real estate, mining ventures and other investments, including Spokane's old Davenport Hotel and the Ox Bow Ranch near Wolf Creek. In his later years, a lot of Republicans regarded Babcock as the titular leader of their state party.

Babcock would collect money from lobbyists and GOP politicians every two years to buy live election night returns from the AP. The group would gather with Babcock at a Helena motel the governor had once owned to pore over the returns and hear him comment on races.

Babcock and his wife, Betty (a prominent member of Montana's 1972 Constitutional Convention), as well as writer Linda Grosskopf, wrote *Challenges Above and Beyond*, the Babcocks' memoir, published forty years after the 1968 election.

Curiously, Babcock's protracted campaign jousts with Anderson over Butte vice, which dominated the front pages of newspapers just before the election, were not mentioned in the book. In fact, Butte was hardly mentioned at all.

Babcock did say in his book that supporting a sales tax ended his political career. The fact he ran for the Senate two years earlier, despite saying he would stay governor for four years, was also mentioned in Babcock's book. He was ninety-five when he died in 2015.

Poor Daly, the Cascade County attorney running for attorney general. He lost the 1968 election to small-town Republican Woodahl, who promised to fight gambling and prostitution wherever he found it. Daly even lost his own county by 404 votes.

Montana would hear a lot more from Woodahl—more than a lot of Montanans wanted to hear—in the years to come as he embarked on a tireless statewide crusade against vice.

Daly received a big consolation prize when Anderson, the new governor, appointed him to fill a vacancy on the Montana Supreme Court as an associate justice, replacing John Bonner, a former governor who died in office. Daly ran for election when his term ended and stayed on the court for thirteen years.[79]

Woodahl's first raid as attorney general wasn't in Butte. His target was Anaconda, west of Butte, where The Anaconda Company smelted the ore mined in Butte, leaving an enormous slag pile. Charges were filed against

Mike Micone, elected Butte mayor in 1969, said in 2015 that there was limited gambling and prostitution during his administration. *From the Great Falls Tribune, John Kuglin.*

four Anaconda bars where Woodahl's men confiscated 176 punchboards and 7 electronic gambling devices.[80] Woodahl's raiders also seized 37 baseball pools, which he considered to be as great an evil as church bingo games.

Mike Micone, who operated a Butte mattress factory with his brother, defeated Mayor Tom Powers by a landslide in the April 1969 municipal election. Powers conceded the election less than an hour after the polls closed.

Powers was active in the Montana League of Cities and Towns and had a lot of political connections. He was hired as personnel director at Warm Springs State Hospital near Anaconda.

Butte's anti-vice leaders had backed Micone, hoping that he would be a reform mayor and clean up the city. Micone succeeded in getting an urban renewal program started. He also helped lead the successful fight to keep The Anaconda Company from dropping the rest of Uptown Butte into the Berkeley Pit.

Boosters of Uptown Butte became alarmed after Martin Hannifan, general manager of Anaconda's Montana operations, told *The Standard,* "Somehow this community must adopt an off-the-hill philosophy. Eventually the community will have to get out of the way of the big industry that supports the town." Hannifan said the city should be moved to the Flats south of Butte. In 2016, Uptown Butte received a boost when NorthWestern Energy, an electric and natural gas utility, completed its new $26 million Montana headquarters building.

Micone promoted city-county consolidation and became the first chief executive of Butte–Silver Bow in 1977. But he never entirely eliminated vice in the old mining town. It is fair to say there was limited gambling and prostitution when he was mayor, Micone told me.[81]

Micone said there were no slot machines or serious illegal poker games in Butte's bars that he knew about when he was mayor. The main problem, he said, was punchboards. If the cops arrested a tavern owner for punchboards,

A large crowd at the Montana Folk Festival in Butte in 2017 near the Original Mine headframe. *From* The Montana Standard, *Walter Hinick.*

The $26 million NorthWestern Energy Building, completed in 2016, is the largest new building in Uptown Butte in recent years. *NorthWestern Energy.*

they would disappear from the rest of the bars, but only for a while. "To get the police department to get rid of them was completely impossible."

Woodahl asked Butte police and the sheriff's department to hit dozens of bars in 1973, citing what he said was an AP report of "relatively open gambling" in Butte. The raids found no punchboards or other gambling in Butte and Silver Bow County. It is more than likely that some of the bars had punchboards before the raid, but bartenders at the first places visited by the cops tipped them off.

Micone was irritated by Woodahl's request for the raid and joined other detractors in calling him "Bingo Bob." Woodahl acquired the nickname soon after the 1968 election when he threatened a statewide crackdown against bingo, singling out Catholic churches, but never followed through.

Ruby Garrett, the woman who gunned down her common-law wife-beater husband in 1959 at the Board of Trade bar would openly operate her Uptown Butte house of prostitution, the Dumas, through part of Micone's administration and beyond.

Sheriff Bob Butorovich closed the Dumas, Butte's last brothel, in 1982 after it was robbed. It never reopened. In a sensational trial, the two robbers were convicted of taking more than $4,500, pistol-whipping Garrett and tying her up along with three of her employees. Garrett testified at their trial.[82]

Garrett pleaded guilty to tax evasion in 1982. She was fined $10,000 and sentenced to six months in prison.

Micone said that before Garrett's house finally closed, prostitution at the Dumas, "like punchboards in bars, was on again, off again." The other houses seemed to be shut down during his administration, the mayor said.

"A lot of residents thought punchboards weren't hurting anything," Micone said, and he didn't recall any complaints about them. He told residents that if they wanted prostitution and punchboards legalized, they should go to Helena and get the laws changed.

Six months after he was elected, Micone sent a thirteen-point directive to Police Chief James Clark, telling him to shape up his department. The chief complied with his directive, Micone said, including his insistence that Clark wear his uniform most of the time instead of civilian clothes and generally keep regular office hours.

Antiques dealer Rudy Giecek acquired the forty-two-room Dumas, Butte's last standing former house of prostitution, from Garrett in 1991 after he promised to operate it as a bordello museum. Later, Giecek turned the Dumas museum over to a prostitutes' group called the International Sex Workers Foundation for Art, Culture and Education.

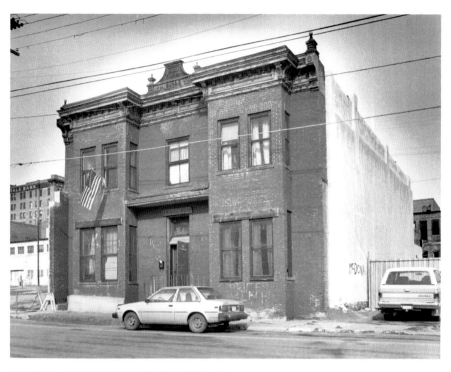

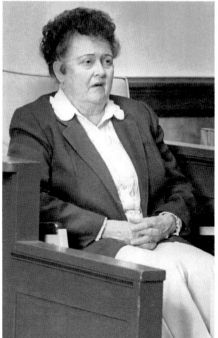

Above: The Dumas brothel owned by Butte madam Ruby Garrett was closed by the sheriff in 1982. Today, it is a brothel museum. *From* The Montana Standard, *Walter Hinick.*

Left: Ruby Garrett, Butte's last madam, testifying in court in 1982 in the trial of two robbers who pistol-whipped her in the Dumas brothel. *From* The Montana Standard, *Walter Hinick.*

The Blue Range building once had prostitutes' cribs. It still stands on Butte's Mercury Street across from the Dumas brothel museum. The doors and windows were for individual cribs. *Walter Hinick.*

The prostitution museum eventually reverted to Giecek. Unable to pay for needed repairs, Giecek sold the Dumas in 2012. It was still operating as a tourist attraction in 2017 and still needed repairs. The Blue Range building still stands with the doors to its individual small cribs facing Mercury Street across from the Dumas.

The Dumas is listed in the National Register of Historic Places and marketed as "America's Longest Running House of Ill Repute" for dispensing sex for ninety-two years until it closed. Elenore Knott, one of the Dumas's madams, reportedly haunts the house. She died in room 20 from an overdose of sleeping pills after her lover, a married man who promised to take her away to a new life, never showed up.

In a remarkable 1991 interview by *Montana Standard* reporter Karl Rohr, Garrett said that prostitution should be treated as a commodity. "If you don't think it's morally wrong, then it's kind of fun," she said.

After Garrett died in 2012, *Montana Standard* reporter Nick Gevock wrote that those who knew Butte's last madam in her later years recalled her as a kind woman who looked after the girls who worked in her brothel and was involved in the community.[83]

Over the years, Woodahl conducted an unrelenting war against gambling, including the ubiquitous sports pools. The attorney general was ridiculed for sending a staffer to the legislature in 1969 to check on reports that senators

and representatives were breaking the law by betting on the Super Bowl. Woodahl tipped off one of the legislative leaders before sending a member of his staff to snoop in the legislative halls. Not surprisingly, the staffer didn't find any sports pools.[84]

This brought a tongue-in-cheek speech on the floor of the House by Representative Pat Williams (D-Butte). Williams said that citizens should know "your members of the House practiced illegal activities" when one-dollar chances were offered to bet on the Super Bowl. Williams was later elected to represent Montana in the U.S. House for a record nine terms.

Turning to small-town vice, Woodahl raided the remote McCone County seat of Circle in Eastern Montana.[85] Seven members of his staff descended on the town of about 1,100 in 1970. They hauled away five slot machines and other gambling devices that had been discovered hidden for decades, dusted off and put to good use in four bars.

Woodahl said he had warned officials in two other counties to remove slots. He said it was a sorry matter when his staff had to interrupt its work investigating alleged voting irregularities and drug abuse "to go out and play policeman and get the job done." He later successfully prosecuted a warehouse owner in Miles City after his staff, in cooperation with federal agents, seized ten thousand pounds of gambling devices, including slot machines, punchboards and pull-tabs.

Before ending good times in Circle, the crusading attorney general turned his attention to vending machines in Billings that dispensed gumballs. Some of the jawbreakers could be redeemed for prizes if they had the right color. Woodahl said the gumballs had to go.

Five years after Butte's Bevgate flap, good times returned to the Mining City in 1973. But only for about twenty-eight hours. The man responsible was state District Judge Freebourn, the same jurist who in 1968 said he would consider calling a grand jury (but never did) to investigate allegations of vice in the Mining City.

Freebourn was presiding over a case brought by Silver Bow County Attorney Larry Stimatz, who wanted to prosecute Nick Elakovich of Butte. Elakovich, represented by prominent Butte attorney Maurice Hennessey, had been arrested at the Blue Bird Bar in nearby Rocker and charged with possessing punchboards and pull-tabs.

Freebourn startled Montana by ruling that the state had no laws that prohibited gambling. He refused to allow Stimatz to file charges, citing, in part, the new Montana Constitution. When voters ratified the document in 1972, they also approved a related proposition that allowed the people or the

legislature to authorize gambling. In 1973, legislators failed to decide what types of gambling the voters had approved the previous year, and that left all gambling legal, Freebourn claimed. The judge also said that the 1973 legislature changed the criminal codes, and the result was reviving a 1937 law that allowed punchboards and card games to stimulate trade.

Until the Montana Supreme Court could hear an "emergency" appeal by Woodahl and Stimatz, punchboards and gambling tables came out of back rooms, and Butte was again a wide-open gambling town. The AP even sent a reporter to Butte to report on the excitement. Then the Supreme Court stayed Freebourn's action until it could hear the case.

The high court, in its final five-to-zero final decision, spoiled Butte's fun, finding

Former state District Judge James D. Freebourn's official photo in the courthouse. His ruling that Montana had no laws prohibiting gambling was overturned by the Montana Supreme Court. *From* The Montana Standard, *Walter Hinick.*

that the 1937 law had been ruled unconstitutional and was not revived.[86] The court said that Freebourn's dismissal of the charges in the Blue Bird Inn case in effect repealed all prohibitions against gambling in the state and that only the legislature or voters could do this. "Such a unique proposition [Freebourn's reasoning] finds no support in law or in fact," the justices held.

Gene Daly, Woodahl's election opponent in 1968, was one of the justices signing the order suspending Freebourn's decision. The high court's decision wasn't popular in Butte. When the new constitution was ratified, 73 percent of the voters in Silver Bow County voted for the gambling proposition. Only 47 percent of them voted to ratify the main constitution.

Freebourn had a better roll of the dice with the Supreme Court after he abruptly halted the 1975 bribery trial of former Butte mayor Tom Powers by dismissing the charges for lack of evidence. As personnel director at the Warm Springs Institution, Powers had been charged with accepting bribes from John L. "Luke" McKeon of Anaconda, the hospital's attorney.

Prosecutors said the bribes were in exchange for giving McKeon confidential information about workers injured at the mental institution so the attorney could recruit clients for his private law practice.

Powers said he gave the documents to McKeon because he was the hospital's attorney and needed to know about injured workers. He admitted receiving money from McKeon but said this was to repay a personal loan to the attorney.

Woodahl appealed Freebourn's ruling to the Supreme Court. In a highly unusual action, the high court voted three to two to subpoena Freebourn to appear before the court to explain why he dismissed the charges against Powers. After hearing from Freebourn, the court voted four to one not to remove him from the case.[87]

The bribery charges against Powers were later dismissed. Woodahl would be more successful when he later prosecuted McKeon on charges unrelated to the attorney general's failed case against Powers.

Two years after the new state constitution made it possible to authorize gambling, the legislature legalized keno and bingo in 1974. A company called Treasure State Games began distributing electronic bingo and keno machines in Montana. Woodahl issued an attorney general's opinion a year later that said the devices were illegal slot machines that had been imported from Nevada. A district judge in Helena held that the machines were legal. Woodahl appealed to the Supreme Court. In a unanimous opinion written by Justice Daly, the court agreed that the machines were legal. Bingo Bob had struck out again.[88]

Woodahl tried to unseat Democratic Governor Tom Judge in the 1976 general election, but the incumbent clobbered him with nearly 62 percent of the vote. Woodahl returned to Choteau to practice law, faded into obscurity and died in 2007.

Father Finnegan went on trial in 1981. Finnegan, forty-two, had directed the Denny Driscoll Boys Home in Butte and the Will and Daisy Brasier Boys Ranch in nearby Whitehall. Prosecutors said that Finnegan coerced three youths at the Butte home to commit homosexual acts with one another and exercise naked in his office. He was also accused of conducting a strip search of one youth and fondling another.

Finnegan testified that the allegations were complete fabrications. His attorneys said the youths were lying because they did not want to be institutionalized. Prosecutors said the youths would not have subjected themselves to the humiliation of a court trial unless they were telling the truth.

The jury returned a verdict of not guilty, but one of Finnegan's attorneys said the allegations had ruined him as a priest. However, Finnegan stayed with the church. For a while, he was a priest in Whitehall, administering the

sacraments to small parishes in the area. He also directed Catholic Charities in Helena. The Catholic Diocese of Helena said he retired in 2002.

Years later, after four years of negotiations, the diocese declared bankruptcy to settle sexual abuse claims. As part of the settlement, confirmed by a bankruptcy judge in 2015, the diocese agreed to post for ten years the names on its website of its priests accused of sexually abusing minors. The diocese had ordained twenty-one of the accused priests. Twenty had died, but Finnegan was still alive.

The diocese's website posting for Finnegan noted, "Criminal accusations were taken to court, resulting in acquittal."

Chapter 11

BUTTE WASN'T THE ONLY PLACE WITH VICE

*Bingo is a violation of the law, and until the Legislature seeks to change it
I will enforce it.*
—Montana attorney general "Bingo Bob" Woodahl [89]

Even "Mr. Clean," as some unhappy citizens called Attorney General
Bob Woodahl, couldn't stop vice everywhere. Montana was just
too big. Gambling and whoring continued around the state, despite
Woodahl's threats and raids after he stormed into office in 1969.

Nearly two years had passed since Woodahl's first gambling raid, which
targeted the Deer Lodge County seat of Anaconda twenty-three miles west
of Butte. The raid netted 220 illegal punchboards, sports pools and other
gambling devices.

Frank Adams, another *Tribune* statehouse reporter, and I decided to visit
the Smelter City to find out if gambling had returned. The punchboards
were in half the bars that Adams and I checked. One of the most popular
boards was the "Midget Ben," which had payoffs of $1 to $5, totaling $60.
Another board, with 1,500 punches, promised total payoffs of $220. The
Tribune published a story under both our bylines that named the bars. [90]

The Ace Bar didn't have a single punchboard, but it did have a
compassionate bartender. Gambling that he'd be paid back, the bartender
added the price of a few drinks and a pint of liquor to the tab of a worker
on strike at The Anaconda Company's smelting complex. "I'll pay you back
when I can," the smelter man said. "I know you will," the bartender said.

Left: Attorney General Bob Woodahl was only partially successful in suppressing vice in Butte. *From* The Montana Standard.

Right: Evidence ticket for the Bank Notes punchboard seized from the Park Bar. *Montana Historical Society Museum, 1982.62.06.*

By now, I had consumed a lot of beer, despite leaving slightly sipped Budweiser longnecks all over Anaconda. We figured the bartenders would be suspicious if we didn't buy drinks. Adams, who didn't touch liquor, was soon drawing attention by drinking straight 7 Up. "Just 7 Up?" asked one surprised bartender. "What do you want with it?"

The Brown Derby bar at Georgetown Lake west of Anaconda, which catered to wholesome fishermen and skiers, was clean. Adams, the designated driver, drove on through the night to Wise River. The little town was worshiped by fly fishermen around the world for the annual salmon fly hatch on the Big Hole River. We thought Wise River was in Deer Lodge County but found out later that we had driven into Beaverhead County.

The salmon flies had hatched three months earlier, and not much was happening in the town. The closest thing to gambling was a private dice game in a bar for small amounts of money, and Wise River seemed squeaky-clean. But another bar a few miles down the road had punchboards and pull-tabs. Woodahl's relentless raiders visited Wise River a week later and seized punchboards from one of the bars.

A punchboard seized from Anaconda's Park Bar during a 1969 raid by Montana attorney general Bob Woodahl's office. *Montana Historical Society Museum, 1982.62.06.*

My phone at home rang early in the morning on the day the *Tribune* printed the story about our gambling survey. It was Woodahl, and he was furious. "How could this be going on in the first place I raided?" he moaned.

Adams and I were summoned to Woodahl's office in the capitol. As we sat there two hours after he called me, the "General," as he liked to be addressed, put his feet on top of his massive antique desk, leaned dangerously back in his swivel chair and had his secretary place a phone call to Deer Lodge County Attorney Ed Yelsa.[91]

Yelsa wasn't at the courthouse, but Woodahl's secretary tracked him down at his private law practice. The General thoroughly reamed out Yelsa, who claimed to be shocked after Woodahl told him there was gambling in Deer Lodge County and it had to stop.

Yelsa did the unexpected by going to state District Judge John McClernan of Anaconda. The judge issued a subpoena that was served on us three days later at the *Tribune*'s Capitol Bureau office in Helena. The subpoena

The 585-foot Anaconda Company stack in Anaconda was abandoned in 1981 after the company was acquired by Atlantic Richfield Company. Surrounded by slag piles, the stack is a state park. *From* The Montana Standard.

commanded us to appear before McClernan to prove that there had been illegal gambling in the county by producing photos or tape recordings to back up our story. All we had were our notes.

Adams and I were relieved after we had a call from Luke McKeon, the deputy county attorney who really ran the prosecutor's office. We knew McKeon, a smart, influential state senator mentioned as a possible candidate for the U.S. House.

McKeon had carried Governor Anderson's bills for reorganizing state government and believed in the art of compromise. "We don't want trouble with the press," he said. I talked to Eddie (Yelsa), and I talked to the judge. You can forget about the subpoena."

McKeon was prosecuted a few years later by Woodahl's office and convicted as a key player in the Montana Workmen's Compensation Division scandal. It targeted attorneys representing injured workers, officials who approved illegal payments and employees in union halls who tipped off lawyers when there were workplace injuries.[92]

Left: State Senator Luke McKeon in 1973. He carried Governor Forrest Anderson's executive reorganization legislation in the Senate. *From* The Montana Standard.

Right: Deer Lodge county attorney Edward Yesla in 1982. He was criticized by Attorney General Bob Woodahl for not suppressing gambling in Anaconda. *From* The Montana Standard.

McKeon was the biggest fish caught by Woodahl and his staff, and one of the few who went to prison. He was disbarred from practicing law but later reinstated by the Montana Supreme Court.[93]

In 1993, McKeon was publicly "censured" by the high court for shoplifting items worth $6.95 from an Anaconda drugstore. He sat silently during the scolding by Associate Justice Fred Weber for stealing two packs of chewing gum and a string eyeglass holder. McKeon's lawyer later criticized the state commission on practice, which hears complaints against lawyers, for being so zealous for a case that involved such a small amount of money. McKeon later retired from practicing law.[94]

Butte wasn't the only place in Montana with brothels—it just had more of them. A few weeks before I wrote the Butte vice series, one of the editors at the *Tribune* sent me to the Yellowstone National Park gateway community of Livingston to write a feature about a man who made jewelry from ponderosa pine cones.

I stopped to say hello to a friend in Livingston I'd worked with when I was a reporter for the Helena newspaper. "We have two houses of prostitution,"

State Senator Luke McKeon in 1989 after he served prison time as part of the Montana Worker's Compensation Scandal. *From* The Montana Standard.

he volunteered. "I think that's pretty good for a little town the size of Livingston." Livingston's houses were still open in 1975 during filming in the area for *Rancho Deluxe*, starring Jeff Bridges. They eventually closed.

In Havre, the upper floor of a building on the main street, had the city's last major house of prostitution operating well into the late 1970s under the tutelage of a madam known as Irene, according to an official report from the local historic preservation commission.

The state's last house of prostitution (not counting some massage parlors) was the Wild Horse Pavilion, a few miles east of Miles City, which had a bar downstairs with strippers. It closed in the early 1990s during a dispute between the owner and the IRS over taxes involving a different piece of property; the state pulled the Wild Horse's liquor license, and the building later burned to the ground.[95]

All throughout the flap in Butte, the well-known brothel in downtown Helena, owned for many years by Dorothy Baker, continued to openly operate. Dorothy's house on South Last Chance Gulch wasn't as lavish as Butte's parlor houses in their heyday but had seven outrageously decorated bedrooms, five "sitting" rooms where customers could check out the girls and two oversized bathtubs. Dorothy's place was furnished like you'd furnish a nice house trailer in the 1950s, before they were called mobile homes.

Dorothy was a very large woman, some guessed her weight at 240 pounds, and her place was a tourist attraction. She had many admirers, either because they were customers or former customers or appreciated Dorothy's unfailing support of charities. She was a respected businesswoman, and fans said she ran a clean and honest house.

Her place was commonly referred to as "Big Dorothy's" or "Big D's," but it was listed as "Dorothy's Rooms" in the telephone directory. Some operators of the tour train that hauled tourists around Helena would point out Dorothy's place as a local attraction. While working for the *Independent Record* in the late 1960s, I was stopped several times while walking along Last Chance Gulch by nervous young men asking directions to Big Dorothy's.

This building on Helena's walking mall housed a respected house of prostitution owned by Dorothy Baker before it was abated in 1973. Today, it houses a sports bar and art gallery. *Tom Kuglin.*

Police Chief Jack Williams and Sheriff Dave Middlemas told *Independent Record* reporter Gordon Warren in 1968 that they didn't know about any prostitution in Helena.[96] That was surprising, as Middlemas had a reputation for being rather straight-laced. The sheriff created quite a stir when he walked into the Bank Club in downtown Helena, at the height of the go-go craze in the mid-1960s, and spotted a young woman gyrating energetically inside a suspended cage. The woman wasn't wearing anything above the waist except two pasties that covered practically nothing. Middlemas told the woman to put on more clothes, and that was the end of go-go dancing in Helena.

"No, we don't have a prostitution problem in Helena that I am aware of. And there certainly isn't anything such as they're talking about in Butte," Williams told Warren. Middlemas, who liked to talk (he had a preachy weekly radio program called *Your Sheriff Speaks*) went even further: "There is no place for a house of prostitution in modern society. If I knew of any brothels that were operating in the county I would close them if I could."

Big D's place wasn't difficult for the sheriff to find: it was two blocks from the sheriff's office, and a red light glowed above the rear entrance.

While the police chief and sheriff denied the existence of her extremely popular whorehouse, Big D's drew customers not only for the girls. Night owls patronized her unlicensed speakeasy, which served liquor after legal closing hours.

Dorothy's was a favorite watering hole for some lobbyists and legislators when the legislature was in session. They'd make a night of it, starting with drinks at Tracy's bar on Last Chance Gulch. Then noodles at one of two good Chinese restaurants—the House of Wong or Yat Son next to Big D's. After that, it was on to Big D's.

Two armed robbers got into Big D's in the mid-1960s by posing as customers when the legislature was in town. I was working for the *Independent Record* when it printed a crime brief about a robbery at a local "rooming house." The story said that one of the gunmen at Dorothy's Rooms had the word *Donna* tattooed over his left breast. Readers who didn't know what really went on in Dorothy's were left to wonder why someone would take off his shirt while robbing a rooming house in the dead of winter. Later, there were some sniggers after Dorothy's Rooms received a $500 urban renewal grant.

Montana Historical Society interpretive historian Ellen Baumler looks at the spectacular ceiling in Dorothy Baker's bathroom at her house of prostitution, which closed in 1973. *From the* Independent Record, *Eliza Wiley.*

Tom Dowling, the young county attorney, filed a civil complaint in 1973 to shut down Helena's brothel as a public nuisance after a previous county attorney, later a Montana Supreme Court justice, failed to abate Dorothy's. Dowling alleged that Big D's was the site of "lewdness, assignation and prostitution." It was the second time Dowling had tried to close Big Dorothy's. She ignored him the first time.

Affidavits supporting Dowling's second attempt to close Dorothy's were filed in state district court by two undercover cops. One was a detective from Kalispell and the other a Missoula County deputy sheriff. The lawmen tried twice to get admitted to Big D's but were unsuccessful. The third time they got in after being met at the door by Dorothy herself, wearing a robe. The detective said they were looking for a room. Dorothy asked if they would like a girl, and they said yes. Dorothy asked where they were from. The cops lied and said they were from Havre.

According to their sworn affidavits, the deputy sheriff was paired with a woman named Marni. The Kalispell detective went to a room with Judy and carefully observed in his affidavit that she was wearing panty hose, a shorty pajama top and no bra.

The detective told Judy, who said she had been selling her body for two years, that he had never been in a house of prostitution. The woman "offered to explain everything to me and then unzipped my pants, saying she had to make sure I was clean," the Kalispell lawman's affidavit said.

The detective then said he didn't know if he wanted to go through with this but asked for a list of prices, which Judy provided. He asked for a drink, and she said he could buy one for one dollar. The affidavit said the detective then gave Judy twenty dollars but didn't say if he received a drink from the unlicensed bar. "I asked her to merely take off her clothes and roll around on the bed, which she did," the detective's affidavit stated. She said to come back in the evening for intercourse if he changed his mind, he said.

The Missoula deputy had a cheaper date with the more experienced Marni, who said she had been a prostitute for four to seven years. She quoted prices for various forms of sexual intercourse and said he could have her for an entire evening for fifty dollars. The deputy, who didn't explain in his affidavit if he was working on a limited expense account, gave her only ten dollars. Marni said this entitled him to only fifteen minutes of sex, the cop said.

He asked for a beer and was refused. After fifteen minutes, Marni told the detective he had to leave. The deputy's affidavit didn't state what he and

Marni did for fifteen minutes, but he generously left her a 50 percent tip of five dollars.

State District Judge Gordon Bennett issued a temporary writ against Big Dorothy. Police raided her house, accompanied by two reporters from the *Independent Record*. Police escorted Dorothy from the house, also her home, and closed her place. Dowling became extremely unpopular with some citizens but had some supporters.

Dorothy had a better than even chance of getting her house back after she hired the state's top criminal defense lawyer, the colorful Charles F. "Timer" Moses of Billings. Moses, who always carried copies of the U.S. and Montana Constitutions in his pocket and would occasionally wave them at jurors, filed a motion to suppress all testimony and evidence gained from entering Dorothy's premises. His motion was simple: there was no search warrant. Dorothy died five days later in a Great Falls hospital. She had diabetes and other health problems, but some people believe she died from a broken heart.

A restaurant and sports bar called the Windbag is now on the first floor of Big D's old place, where legislators and lobbyists still gather during the session. The Windbag sells its own private label wine, "Big Dorothy's Whorehouse Red."

Chapter 12

A NEW LIFE FOR
BEVERLY SNODGRASS

*Behind its crumbling façades are vast libraries, art works, antiques, silver,
crystal—there's a level of sophistication in Butte that I haven't found elsewhere.
—Gus Miller, active for many years in the city's cultural activities, including the
Butte Center for the Performing Arts*[97]

The last time I heard from Beverly Snodgrass was after she left Butte
and wrote me a letter from Charleston, West Virginia, where she had
family and was again waiting on tables. "Nothing has gone well back
in this country, but I have managed to cope with matters up until now," she
wrote late in 1968.[98]

She planned to go to Idaho. Then she could slip into Butte when
necessary to visit the veterinarian who had tended her poodle pack, hoping
he "will find them a proper home because I can no longer give them the
proper care."

She left one of her poodles in Butte after it died. Bev buried her beloved
pet in a white baby's coffin obtained from a Butte mortician. Her dog's
grave was under a pine tree near her first house of prostitution, at 14 South
Wyoming. The pine tree and presumably the tiny coffin under its roots are
still there.[99]

In Charleston, Bev's boss at the restaurant didn't fire her after she told
him about her connection to Butte prostitution. But she was evicted from her
apartment after a story in a Charleston newspaper reported about her shady
past as a madam in Butte.

I was working for the AP in Helena in 1980 when Frank Adams, my former colleague at the *Tribune*, interviewed Butte's famous former madam.[100] Adams, still covering the statehouse for the *Tribune*, reported that "she's still working with girls—but in a quite different way—as a counselor in another state."

Bev told Adams during the telephone interview that she felt in danger if she stayed in Butte. "I had to move from place to place for a while, and then I settled down and went to college." She said she stopped drinking, received a degree in social work and began working with troubled teenagers. At fifty-nine, she said her red hair had turned brown. The former madam said she had a genuine religious conversion before I interviewed her in the office of the Butte priest in 1968.

Adams wanted to talk to Bev because of something he was told a few weeks before by the Butte official nicknamed Dimple Knees, whom the madam said became her lover so he could gradually take over her prostitution business. The official told Adams that Bev called him in 1973 to apologize and admitted she made the whole thing up, at Finnegan's direction, when the priest was a leader of Butte's anti-vice crusade.

Adams said he'd be happy to correct the record but was told by Dimple Knees that "I'd have corrected it a long time ago if I wanted to." The official denied hearing the name Dimple Knees before it was printed in the *Tribune*.

Bev told Adams that she did phone Dimple Knees, but it was on New Year's Eve 1971. "And the only thing I said was 'Happy New Year, you SOB.'" Bev told Adams that "everything that I told, every word that I spoke, was true. I did not lie one time."

Bev said that she, not Finnegan, initiated the *Tribune*'s exposé. Finnegan was one of the very few who stuck by her once she did speak. And the *Tribune* was the only paper willing to do the story, she said.

The politician wasn't telling the truth when he claimed he never heard the name "Dimple Knees" until the *Tribune* printed the name, Bev said. It wasn't just Dimple Knees who was crooked, she said. "It was the group. It is a syndicated city. There's a lot of people who were raised there; they've been there all their lives and they stick together. If one of them gets into trouble, the rest are there to help get 'em out."

Chapter 13

REQUIEM

To some of them it wasn't just a house, it became almost like a home.
—Beverly Snodgrass, describing the prostitutes in her brothels[101]

Dimple Knees' brother Bill died on a summer day in 1970 in Jefferson County north of Butte. He was only fifty-six. Bill had been identified by Beverly Snodgrass, her employees and a private detective as the bagman who collected most of her payoffs to Butte officials.

The death certificate said Bill died from "accidental" causes after the prominent Butte attorney "fell into [a] hot pool" and drowned inside the rambling old Diamond S. Ranchotel at Boulder Hot Springs, halfway between Helena and Butte.[102] The lawyer's death was unusual enough to rate an autopsy. The autopsy report said Bill apparently slipped after leaving a steam room and fell into the plunge.

The first part of the hotel, with unique Spanish Revival architecture (rare in Montana), was constructed in about 1881. Water in the plunge where Bill died was usually a bit above one hundred degrees Fahrenheit. The autopsy showed that Bill had a blood alcohol content of 0.21 percent, current coroner Craig Doolittle told the author. This would have been more than twice the BAC level for driving while intoxicated in Montana in 1970.[103] No one said what drew the attorney to the hot springs to apparently die alone in a hot pool.

Bill's widow, the administratix his estate, filed a wrongful death suit against the hotel and its two owners. She sought $151,059, including $1,056

Dudes in the 1960s ride in front of the rambling Diamond S. Ranchotel. Dimple Knees' brother drowned inside the hotel in 1970. *Butte–Silver Bow Public Archives, MC933.041.02.*

for her husband's funeral. The suit alleged that the hot springs hotel failed to provide lifeguards and supervision at the plunge where Bill's body was found. The owners of the hot springs hired prominent Anaconda attorney Wade Dahood, later a leading member of Montana's 1972 Constitutional Convention. Bill's widow settled for $5,000.[104]

Beverly Snodgrass was sixty-five when she died in 1987 in Washington State. The woman who had brought so much publicity to the Richest Hill on Earth, whose name became a household word in Montana, received a ten-paragraph obituary in *The Standard*.[105] The obit contained bare details, including Bev's birth in West Virginia and her first job in Butte as a waitress. Brief mention was made of Bev's 1968 allegations to the *Tribune*, when she described her sizzling career in Butte's thriving prostitution industry and bribes to local officials and police.

After she left Butte, she moved briefly to Charleston, West Virginia, Idaho, Oregon and Walla Walla, Washington, where she studied counseling at a community college. She later was a counselor at a state institution in the Seattle area. Bev said she had undergone a religious conversion. Before she died, she was working on a book about her life and conversion as a born-again Christian, her obituary said. Bev's obituary noted that memorials could be given to the New Silver Bow Zoo.[106]

Reynolds wrote in the *Missoulian* after Bev's death, "Ah, how the memories flooded back when news came that Beverly Snodgrass had departed this world." He recalled that in 1968 "a series began to crash across the *Tribune's* front page. Montana ran for cover. Houses of prostitution closed. Tavern gambling stopped. What was the 'Butte Thing' began."

Reynolds assured the *Missoulian's* readers that he never met the famous madam, never visited her houses in Butte and never met her lover, Dimple Knees, one of the local officials whom she allegedly bribed to protect her "enterprising businesses." He closed his column with "Beverly Snodgrass, rest in peace."

Former Butte Mayor Tom Powers, who claimed that the city's citizens wanted prostitution and gambling, died from cancer in 1988. Powers thought he would be reinstated as personnel director at Warm Springs after bribery charges against him were dismissed in 1975. But he didn't get his job back after a state audit showed he had signed off on some contracts for work charged to the institution that was never performed. He declined another state job in Helena and for several years was a custodian for Butte schools.

Powers carried a rifle on Omaha Beach during the World War II invasion of Normandy. In his later years, he was an advocate for better veteran benefits. His obituary in *The Standard* said that when Powers was defeated for mayor in 1979, "the underlying issue in the election was that Butte was riddled with prostitution." But Powers was never linked to prostitution, the newspaper declared.

Former District Judge James Downer Freebourn of Butte, who made the short-lived ruling that legalized gambling in the state and dismissed bribery charges against Powers, died in 1998. He was eighty-six and had spent sixteen years on the bench.[107]

Rick Foote, former editor of *The Standard* and then editor of the *Butte Weekly* newspaper for several years, wrote a tribute to Freebourn after the judge died.[108] Foote noted that the judge had a strict work ethic, became his mentor and taught him how to cover the courts in Butte in the early 1970s when Foote was a reporter for *The Standard*.

Foote said the first thing he did was ask the judge "for his advice and assistance in covering the complexity of the courts and environs. And assist he did." Foote said the judge told him it was mandatory to attend his law and motion days. The judge also insisted that Foote provide gavel-to-gavel coverage of trials to foster public understanding of what was happening in court. "Many a time I was called before the bench to explain a late arrival at law and motion day," Foote wrote. "There could be no bounding in and out

taking snippets of testimony here and there and then pretending as if that was trial coverage."

Foote, who died in 2013, wrote that the judge enjoyed a nip or two, liked to gamble and "in the parlance of the street he had juice. He rarely used it. He didn't have to. He was the judge. They made him and broke the mold."

As a former district judge, when Freebourn died he rated a front-page story in *The Standard*, along with a separate obituary.[109] The story said that Freebourn's "compassion and sense of fairness guided his work on the bench of the Second Judicial District Court, friends said."

Freebourn studied law by enrolling in a correspondence school and began practicing law in Butte in 1941. He was an officer in the merchant marine during World War II and spent twenty months in the South Pacific. He played baseball for the Butte Copper Sox when he was younger and was a good golfer. He was married and had two sons. Freebourn was Silver Bow county attorney for three terms before he went on the bench.

In 1960, he narrowly lost a nonpartisan race for an open seat on the Montana Supreme Court.[110] He was elected district judge in 1964. The judge's last day on the bench was in September 1980, when he heard two divorce cases. He resigned two years before his term expired, saying he was "getting a little old" for the rigors of the courtroom.[111]

State District Judge James Freebourn presides over his courtroom for the last time, September 30, 1980. *From* The Montana Standard, *Walter Hinick.*

Governor Tom Judge appointed Mark Sullivan to replace Freebourn. Sullivan was the Silver Bow county attorney in 1968, when he resisted calls from anti-vice groups to petition the district judges to call a grand jury to investigate Butte vice and corruption.

What kind of judge was Freebourn? In 1975, he locked up school trustees and union representatives until they settled on wages for the next school year. He had a running feud with County Attorney Gary Winston, who said, "I just don't think I can get a fair shake in front of Freebourn." Winston said his staff was "scared s---less to be up there" before the judge.[112] "You don't get to present evidence in front of Freebourn. He's made up his mind before you even get to court."

Freebourn was rude, defiant, constantly interrupted cross-examinations and did not allow evidence to be admitted, Winston said. Freebourn said he wasn't biased against Winston. The judge said he merely enforced strict standards for introducing evidence.

Dick Dzivi was Woodahl's high-profile special prosecutor when he failed to win a bribery conviction against Powers when Freebourn was hearing the case. When the state complained to the Montana Supreme Court, Dzivi, former president of the state Senate, said that he resented Freebourn's "left-handed, snide accusation of an incompetent prosecution."[113]

Al Carruthers, owner of the Derby, told *The Standard* after Freebourn died that the judge was a fixture at his bar and played the ponies until several weeks before his death. "I was very lucky to have worked for him," said Linda Connors, a court reporter when Freebourn was on the bench. She said Freebourn spent a lot of time in the law library and behind a manual typewriter crafting his orders. She said the judge worked alone without a secretary or law clerk.

State District Judge James Purcell of Butte practiced before Freebourn before Purcell was elected to the bench. "He was a very fair man," Purcell said. "He was like any judge. He had his likes and his dislikes—but in my opinion he never demonstrated them in open court."

One of Freebourn's longtime friends, Reverend Sarsfield O'Sullivan, said that the judge was "the sort of man who had great affection for people." The priest remembered Freebourn listening intently to his homilies long after others had lost interest, a courtesy the judge gave to anyone.

No one mentioned the dimples in the judge's knees.

EPILOGUE

Everyone has to have sex. None of us got here by looking at each other.
—Dolores Arnold, a popular madam with two whorehouses in Wallace, Idaho[114]

Five years after the *Tribune* printed the series about Beverly Snodgrass, I was again covering a story about houses of prostitution. This was two months after I started working for AP in Spokane, Washington.

It was 1973 and the politicians in Idaho's state capitol in Boise had just closed the houses of prostitution in the Coeur d'Alene Mining District. I was assigned to cover the story.

The five busy brothels were in Wallace, a Northern Idaho Panhandle town of 2,300 about eighty miles east of Spokane. It was easy to find Wallace's houses of prostitution. Most of them were upstairs from storefronts in the small business district of brick buildings, about half a block from city hall. The houses had bright neon signs and discreet back entrances.

Before they closed, customers could choose between the Lux, Luxette Rooms, the Sahara, Oasis Rooms and the U&I, jokingly called the northern campus of the University of Idaho. Wallace was in Idaho's Silver Valley, which mined more silver than any place in the nation. The old mining town had a lot in common with Butte.

Thousands of miners worked in the deep silver and lead mines around Wallace and the Bunker Hill Company's huge lead smelter in nearby Kellogg. The incredibly rich silver mines, some yielding more than twenty ounces of the valuable metal in a ton of ore, went even deeper

than copper mines in Butte, to 6,900 feet. The mines were so deep that they were plagued with "rock bursts," where rocks under pressure would explode without warning and ricochet though the workings, killing or maiming miners.

In addition to prostitution, there was open, illegal gambling in the mining district, including slot machines. My brother, Chuck, came to visit, and I took him to the small former gold mining town of Murray in the mountains above Wallace. He put a dime in one of the slots, and it spit out enough dimes on the floor to fill two pockets. He scooped up the dimes and eventually lost his winnings before he quit. The slots were seized a few weeks later by federal agents.

Like Butte and Anaconda in southwestern Montana, the Silver Valley in the early 1970s was an environmental disaster. Pollution was so thick from the Bunker Hill smelter that if you left your car parked outside overnight in Kellogg and the wind was right, it would be covered with yellow dust smelling like sulfur in the morning. You would have to brush the dust off the windshield before you could see to drive.[115]

The South Fork of the Coeur d'Alene River downstream from Kellogg was dead for miles. It was called Lead Creek locally, and the colorful stream of pollution flowed in a rainbow of colors—mostly red, yellow and green—bearing toxic industrial waste from the barren area where smelter fumes had killed most of the trees.

I would occasionally go into the mines to write stories. One story was about the strange gardens miners grew in their spare time deep in the Bunker Hill Mine. They were ordinary gardens like you'd find in someone's backyard, with flowers, fruits and vegetables. But the plants grew under light bulbs and thrived in the moist hothouse temperatures. The gardens got their start when miners threw away the pits and seeds from their lunch pails.

Over the years, the miners raised cherry, prune, lemon, grapefruit, apple trees and blooming cactus that flourished in depths up to five thousand feet below ground. But the trees bore no fruit. Like Jack's giant beanstalk, the bean plant had to be removed before it took over the mine, a miner said. Sometimes it grew a few inches a day.

In the gulches a few miles from the Silver Valley, partially burned "ghost cedars" still stood from a Connecticut-sized forest fire in 1910 that burned a large part of Wallace as it raced through Northern Idaho, Western Montana and Eastern Washington.

Some of the burned cedars, their trunks still standing more than sixty years later, sprouted new growth from their trunks. Someone cut a hole for a

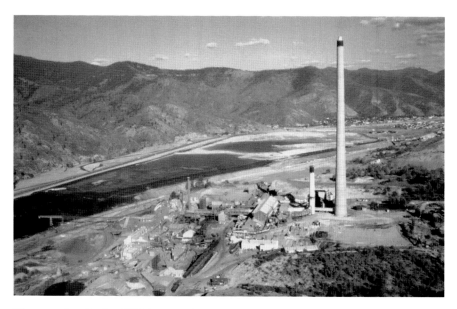

The sprawling Bunker Hill Company lead smelter near Kellogg, Idaho. *Wallace District Mining Museum.*

door in one large, hollow cedar near an informal campground and installed a seat for an outhouse.

Kellogg's children were polluted as well. A 1974 study by state health officials showed that all but 2 of 175 children living within a mile of the Bunker Hill smelter had abnormally high lead levels in their blood; 37 others had actual lead poisoning. Dave Smith, the local Chevrolet dealer, criticized the state for releasing the test results. Smith said that the Kellogg Wildcats football team, which had a ten-game winning streak in the last season, showed that the area's children were healthy.

In the smelter itself, workers would get "leaded," or injected with chemicals to flush out the toxic metal, and be sent back to work.

I once wrote a story about Deadwood Gulch on the edge of Kellogg, less than three quarters of a mile from the smelter, built in 1917. The gulch contained about twenty houses and was filled with rusting car hulks and piles of mine tailings. One of the residents, who held a coughing child, told me, "I figure he's got lead poisoning." She was waiting for test results. Another woman said that at times the pollution was so bad babies were put in one room and a fan was turned on to keep the air clear. "It takes their breath way. It about kills them," she said.

The Bunker Hill smelter, like the Montana copper smelter in Anaconda, was extremely productive. In the early 1970s, it had a yearly output of about 130,000 tons of lead, 145,000 tons of sulfuric acid, 7.7 million ounces of silver, 1.1 million pounds of cadmium and 98,000 pounds of zinc and arsenic. A lot of the ore was hauled up from the Bunker Hill Mine.[116]

Miners and smelter workers in the Silver Valley, like in Butte and Anaconda, looked for diversions after their shifts ended. If they had a few days off, they might escape with their families from the dirty jobs in the mines and smelter and drive into the mountains. The area around Wallace was stunning, with giant cedar trees that hadn't burned in the 1910 fire, miles of mountain streams filled with cutthroat trout and unbelievable elk hunting. A challenging ski area, Silver Bowl, had runs down a mountain above Kellogg.

Like in Butte, bars ignored state liquor laws. People in the Silver Valley said the laws had been passed by potato farmers and churchy conservatives in southern Idaho who didn't know how to have a ripping good time, including drinking, gambling, whoring and fighting.

It wasn't legal for Idaho bars to serve hard liquor on Sunday. You could still get it in the Silver Valley if you knew what to say.[117] When a bartender asked what you wanted to drink on the Sabbath, an acceptable response would be something like, "I don't feel well. I need some medicine."

"What kind of medicine?" the bartender would ask. A thirsty customer might reply, "Maybe...um...a screwdriver." The bartender would unlock the hard liquor, pour a shot and a half of medication into a glass of canned orange juice and ceremoniously lock up the bottle of vodka while everyone laughed at the bar.

A lot of people in Northern Idaho also railed against a state law, loosely enforced in the area, requiring bars to close at 1:00 a.m. As last call was announced in Lewiston south of Kellogg, there was an exodus across the Snake River bridges to its twin city of Clarkston, Washington, where bars stayed open another hour.

Wallace's famous brothels attracted customers from a wide area that included Eastern Washington, Western Montana and motorists driving through on their way to Seattle, Portland or Minneapolis.

No one claimed to know why the houses had been closed before one of their busiest times—near the start of the hunting season—but the last session of the Idaho legislature had enacted harsher penalties for prostitution. The most popular theory was that Governor Cecil Andrus sent the head of the

The memorial to the ninety-one miners who died in 1972 in the Sunshine Mine fire near Kellogg, Idaho. *Wallace District Mining Museum.*

state police to tell Wallace officials they had a choice between closing the houses or raids by troopers.

After a meeting in May, local officials reluctantly told the madams to close the houses by the end of September. Wallace City Attorney Dennis Wheeler would only say the houses "were closed as a result of cooperation between state and local authorities."

The blow to the economy came while the Silver Valley was still mourning the deaths of ninety-one miners the previous year when fire swept the Sunshine Mine, the nation's richest silver producer, between Wallace and Kellogg. And now the houses had closed.

Abating the houses had shocked Dolores Arnold perhaps most of all, as the proud owner of the Lux and Luxette Rooms. Dolores, who had recently outfitted the entire high school band with fifty-dollar uniforms, told me that the entire mining district was unhappy over the shutdowns. "It was terrible to turn the men away," she said. "They kept driving around my houses, honking their horns, looking for relief, and I couldn't help them."

When questioned about the moral issues of operating a business where women sold their bodies for sex, Dolores flatly replied, "The moral part is that the men get relief. What in the hell is wrong with that?"

My friend John McGee, manager of the Wallace Elks Club, said that Dolores hosted an annual Christmas dinner party in one of her respected houses for the Gyros, a local businessmen's group. Her girls took the evening off to wait on the town's movers and shakers.

McGee was writing a book about Wallace's whorehouses. The title was *Coming Through!* This was the warning yelled by prostitutes when they were bringing a client down a hall to a room. McGee died before he completed his book.

Dolores and the other madams got together to buy a new scoreboard for the high school athletic field. She also sent food baskets to the families of miners who died in the Sunshine Mine fire. To stimulate business, Dolores distributed hundreds of free calendars featuring the Luxette and Lux. They showed pictures of beautiful, scantily dressed young women above the words "Our real beauties are our personal service and quality." The calendars promised customers TV in the lobby, and Dolores pointed out that some of the rooms in her houses had stereo music. "I run a classy operation," Dolores said. "I have the best houses, the best girls in town."

The high school principal said he didn't think he should talk to me. When I pointed out one of the Luxette's calendars on the wall of his office, he said, "Everybody has them."

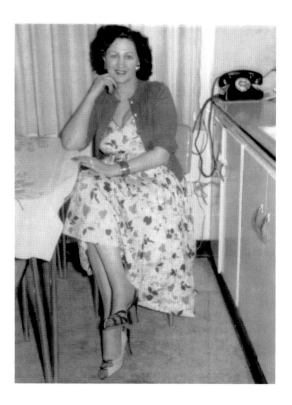

Dolores Arnold, the most prominent madam in Wallace, Idaho, sits in the 1950s near her rotary telephone in the Luxette Rooms, one of her two houses of prostitution. *Wallace District Mining Museum.*

Unlike in Butte, there were no groups of anti-vice crusaders in the Silver Valley. The only person in town who seemed happy the houses had closed was Reverend John Sandford of the United Church of Christ. "I said, praise the Lord. It was the answer to our prayers," the minister said. He admitted that many members of his congregation didn't share his joy.

Sandford said he had just been forced to resign his pulpit after disagreeing with his flock over several issues, including prostitution.

Just about everyone I talked to in Wallace said they feared a dramatic rise in rape and venereal disease if they couldn't reopen the houses. "I only hope the victims are the wives and daughters of those responsible for the closings," said Ray Kannegard, a miner. "I think the houses are a nice thing to have in a community. I used to go when I was a single man and was real satisfied."

Whoever was responsible for closing the houses, citizens were livid. Many blamed Cecil Andrus, at one time popular in Northern Idaho. Bartenders operating near the brothels said they brought business to the community—not only from local smeltermen and miners but also from regular customers in neighboring states. "It was a great thing, the houses. I can't think of

anyone in town who wasn't helped by them," said bartender Jim Bury as he poured drinks at a bar downstairs from one of the houses.

Most of this unhappy town's residents agreed with Ray Giles of the Wallace Chamber of Commerce. Giles condemned "other people, standing knee-deep in filth, pointing the finger at Wallace." Giles, a mining engineer, believed residents thought it was better to have whorehouses instead of the massage parlors advertised in other towns like State Line, Idaho. Or street walkers in Spokane.

Shoshone County Prosecuting Attorney Richard Magnuson said he did not receive a single complaint about the houses during his thirteen years in office; he blamed the state for closing them. Magnuson said he had prosecuted only one rape case in the past year and a half. The prosecutor attributed the low rape rate to the houses. He said that Wallace had no streetwalkers.

The girls and some of the madams had left town by now, the neon signs were turned off and the only visible action in Wallace bars was betting on football pools and shaking dice for jukebox music. What occurred next showed what happened when the news staff of the AP, which had bureaus in Seattle and Salt Lake City, along with smaller correspondencies in Spokane and Boise, didn't talk to one another.

My story was edited and filed by the AP Seattle bureau on state news wires for Washington and Idaho. A more tightly edited version was sent to the AP general news desk in New York City. An even shorter version was filed on the news cooperative's regional broadcast wires. Five minutes after my story had clanked out at a little over sixty words a minute on Teletype machines at AP-member newspapers in the two states, a strikingly similar story moved on AP wires for the two states.

The second story, also with a Wallace dateline, had the byline of Bob Leeright, veteran AP Boise correspondent in southern Idaho. What happened?

Northern Idaho was supposed to be covered by the AP Spokane bureau, which was a lot closer than Boise and wasn't Leeright's turf. But Leeright was from Northern Idaho and knew this was a big story. As soon as he heard the whorehouses had been abated, he drove at breakneck speed to Wallace.

Leeright and I had unknowingly followed each other around Wallace, talking to many of the same people, including Dolores Arnold. His story was edited and filed through the AP bureau in Salt Lake City.

Wendell Brainard was the soft-spoken editor of the *Kellogg Evening News*, the only daily newspaper published in the Silver Valley. The small newspaper

took an AP wire, and Brainard said he didn't know what possessed the wire service to write a story about closing the houses, let alone two stories.

The *Evening News* usually printed any AP story with an Idaho dateline unless it was about growing potatoes in southern Idaho. So Brainard, despite his personal feeling that closing the houses wasn't news, dutifully published both similar AP stories.

Brainard displayed the stories side by side.[118] He generously awarded both of us bylines under a headline that said, "Wallace Houses Closure Still Stirs Up Writers."[119] Two months after our stories were distributed, Andrus picked the Silver Valley for one of his "Capitol-for-a-Day" visits. A miner angrily confronted the governor during his tour and told him to "keep your nose out of Northern Idaho." I wrote a story that led with the encounter.

Andrus had been popular in Northern Idaho. He had worked in the timber industry in central Idaho and later sold insurance in Lewiston. I received a letter from Andrus a month later, stamped with Idaho's great seal. The governor wrote that he appreciated the "diligent coverage" and thanked me for the "considerable time and attention you gave to covering my recent Capitol-for-a-Day visit to Shoshone County."

By now, the houses had reopened as mysteriously as they had closed, but some people speculated that Silver Valley mining king Harry Magnuson had something to do with it. Nobody was talking. The people in Shoshone County were just happy that it was business as usual.

Dolores Arnold and the town's other madams soon restocked their houses. Dolores had a good run and made a lot of money before she finally retired and moved to Reno, Nevada. The last house of good repute in Wallace, the U&I, eventually closed after fear of AIDS raised concerns about casual sex with strangers.

One of Wallace's former houses is now the Oasis Bordello Museum. The house closed in 1988 before an anticipated federal raid. The tour includes "Madam Ginger's" bedroom. On the wall is a lengthy and explicit schedule of house rates. Like many houses of prostitution, the girls collected the money in advance from their customers. They gave the money to the madam before returning to go to work. A few of the charges at the Oasis:

- straight [no frills] 8 minutes, $15.
- straight [regular] 13 minutes, $20.
- straight French, $30.
- doubles, double charges.
- positions, $5 each.
- bubble bath, 1 hour, $80.

NOTES

Prologue

1. Chatham said this in a publisher's note when his Clark City Press reprinted Richard O'Malley's *Mile High Mile Deep* in a handsome new edition in 2004.
2. Interstate 90 north of Pipestone Pass became the main east–west highway though Butte after Homestake Pass was opened in late 1966.
3. While Butte citizens commonly called the dominant mining corporation "the Company," its name changed many times over the years. In 1880, it was the Anaconda Gold and Silver Mining Company; in 1891, Anaconda Mining Company; in 1895, Anaconda Copper Mining Company; in 1899, Amalgamated Copper Company, a holding corporation; in 1915, Anaconda Copper Mining Company again; and in 1955, The Anaconda Company. The corporation was sold to Atlantic Richfield Company (ARCO) in 1977. Information comes from the Montana Historical Society.
4. The 93,000 figure for Butte and the surrounding area is from the 1918 R.L. Polk Company Butte City Directory. Some people believe that Butte once had 100,000 people. A U.S. Census Bureau estimate in 1917 showed 93,981 people living in Butte and 36,212 for the rest of the county. It should be ignored. The 1917 estimate also grossly overestimated Montana's population at 952,478, compared with 548,889 in the official 1920 census. Montana's population wouldn't exceed 900,000 until the 1990 census. Butte's population dropped dramatically after World War I. The 1920 census showed a decline to 60,313 people in Silver Bow County, including Butte. Butte's population has now stabilized at about 34,000.

Chapter 1

5. From the Snodgrass Report, compiled by private detective W.F. Sanders, hired by Beverly Snodgrass.
6. The author interviewed Snodgrass in July 1968. The interview was published in the *Tribune* on October 13, 1986, 1.
7. "Suspicious Fire in the Windsor Block," an undated report written in 1968 by Assistant State Fire Marshal Jens Boland.
8. The Pub was not unlike the tavern Cheers in the long-running TV sitcom starring Ted Danson. Helena's Pub was a place where customers became engaged, asked spouses for a divorce, swapped spouses and girlfriends, planned ski trips and, of course, told their troubles to the bartender. Sadly, the Pub was torn down to provide space for a parking lot.
9. Tom Mooney, a capable and experienced journalist, once worked for the Butte newspaper. He was executive director of the Babcock for Governor Club. I worked in the same newsroom with Mooney for several years before I left to work for the *Tribune*.
10. Jerry Madden was a relentless and feared reporter who improved the *Tribune*'s statehouse coverage. His investigative stories included one about a state prison inmate who died in the "Hole," a solitary detention cell in the state prison where temperatures exceeded one hundred degrees. Another story reported on large cracks in the concrete of a newly constructed interstate highway. Madden also wrote a weekly column about politics that was almost required reading for state employees.

Chapter 2

11. Richard O'Malley was a Montana newspaperman who became a famous foreign correspondent for the Associated Press and covered the surrender of Japan in Tokyo Bay in 1945. Like O'Malley, I was a reporter for the daily newspapers in Missoula, Helena and Great Falls before working for the AP.
12. *Montana Standard*, June 9, 1959, 1, 11.
13. Administrator's deed (indenture) filed April 24, 1961, Silver Bow County Clerk and Recorder's Office.
14. Snodgrass Report, 1.
15. A deed to convey the house to Rogers was recorded on December 30, 1964, in the Silver Bow County Clerk and Recorder's Office. The second

deed, when Bev bought the house back from Rogers, was recorded on August 13, 1965. Bev's repossession of her house in August may have been because she was having trouble being paid by Rogers. Dimple Knee's brother, Bill, also notarized the deed after Bev sold the Windsor, her second Butte brothel, courthouse records show.

16. Author's interview with Snodgrass, *Tribune*, October 13, 1968, 1.

17. The city directory didn't list anyone named Beverly M. Kobe. Dimple Knees once had a Butte florist send the madam flowers with an envelope attached that said it was for "Beverly Kobe." Maybe this was a private joke between Bev and her boyfriend.

18. Author's interview with the Smiths in Butte, October 4, 1968.

Chapter 3

19. *Missoulian*, February 5, 1976, 4.

20. All direct quotes in this chapter—most of them from Beverly Snodgrass—are from the Snodgrass Report, unless otherwise designated in the text or chapter notes.

21. Told to the author in Butte by Bert Gaskill, October 18, 1968. The editor of *The Standard* had lived until recently at 2034 Locust, according to the 1967 city directory. Beverly's love nest with Dimple Knees was at 1911 Locust, one block from Gaskill's house.

22. *Missoulian* column by Sam Reynolds, October 9, 1987, 4.

23. Letter from Beverly Snodgrass to Anthony Keast, September 7, 1968, mailed from Port Amherst, New Jersey, to Missoula, Montana, in possession of author.

24. Letter from Keast to Snodgrass, September 16, 1968, mailed from Missoula to Port Amherst, in possession of author.

25. Montana Supreme Court, first Order of Disbarment for Anthony Keast, May 15, 1972, Montana Law Library.

26. Montana Supreme Court, second Order of Disbarment for Anthony Keast, June 6, 1989, Montana Law Library.

27. *Missoulian*, October 14, 1988, 1.

28. The author obtained a copy of the notarized criminal affidavit, which was not part of the Snodgrass Report.

Chapter 4

29. The author's first night (and morning) on the town was in July 1968. Little had changed three months later, when the author returned to Butte to update the story before it was published in the *Tribune*, October 17, 1968, 1.
30. Finnegan said that one of Butte's four remaining houses of ill repute closed voluntarily on June 19, 1968, and the other three closed the following day. Some houses later reopened.
31. Author's conversation with McFadden, *Tribune*, October 17, 1968, 1, 2.
32. Figures on the number of licensed bars in Butte, Billings and Great Falls were supplied by the Montana Liquor Control Board, *Tribune*, October 18, 1968, 2.
33. *Esquire* (March 1970).
34. Told to the author by private detective W.F. Sanders.
35. This figure also came from Sanders, who called it a "very rough estimate."
36. Pasties is the plural for the meat and vegetable pie called a pasty, often carried by miners in Butte for lunch. Pasties are also the small coverings that exotic dancers and strippers sometimes attach to their nipples so they won't violate anti-nudity ordinances.

Chapter 5

37. *Montana Standard*, February 23, 1991, 4.
38. *Tribune*, October 18, 1968, 1.
39. The original concrete *Jungle Fighter* statue, placed in 1943 during World War II, has now secured high ground at the top of the steps outside the front entrance to the Butte–Silver Bow Courthouse. A bronze replica cast in 1966 is in a Butte park. The sculptor was John Barney Weaver, who also created the bronze of famous western artist Charles M. Russell in Statuary Hall in Washington, D.C.
40. Letter from Hardin to Mayor Powers, June 21, 1968.

Chapter 6

41. *Butte Miner*, January 19, 1902, 2.
42. Ibid., 6, 7.

43. *Butte Miner*, October 17, 1907, 8.
44. Butte and its suburbs had 267 saloons listed in the 1910 city directory.
45. *Montana Standard*, October 18, 1968, 6.
46. Author's interview with John McNellis, *Tribune*, October 20, 1968, 2.
47. Author's interview with Harold Pitts, *Tribune*, October 20, 1968, 2.
48. Dr. John Anderson left his "crime breeding volcano" message on the father's answering machine, May 15, 1968.
49. Author's interview with Finnegan, *Tribune*, October 20, 1968, 2.
50. Author's interview with John McNellis, *Tribune*, October 20, 1968, 2.

Chapter 7

51. Author's interview with Knievel, *Tribune*, *Montana Parade* section cover story, May 16, 1969.
52. Miller's distribution of "I'm from Butte, America," bumper stickers was mentioned in his obituary, carried in newspapers across Montana, after he died December 7, 2009.
53. The Senate adopted the bill outlawing DST on January 21, 1965.
54. Babcock vetoed the bill outlawing DST on March 2, 1965.
55. "Butaconda" editorial, *Montana Standard-Butte Daily Post*, March 3, 1965, 4.
56. *Proceedings and Debates of the Montana Constitutional Convention*, 751.
57. Devoto, *Mark Twain in Eruption*.

Chapter 8

58. In the late 1960s, there was rivalry to keep and recruit subscribers between the *Tribune* and Lee newspapers. *The Standard* was unhappy because the *Tribune* poached readers in Butte and Dillon south of Butte. The *Helena Independent Record* viewed the *Tribune* as stealing its readers in Helena, where the *Tribune* had a good statehouse bureau and a lot of subscribers. The *Tribune* butted heads with the *Missoulian* in northwestern Montana and Missoula itself. In eastern and central Montana, the *Billings Gazette* and *Tribune* were in a perpetual circulation war, especially along the Hi-Line, a string of small cities and towns spaced for hundreds of miles across the top of Montana, not far from Canada. The *Missoulian* and *The Standard* fought each other for readers in small cities like Drummond and Deer Lodge, midway between the papers.

59. *Montana Standard*, October 20, 1968, 6.

60. *Montana Standard*, October 21, 1968, 4.

61. The article about the shutdown of gambling and prostitution in the Great Falls area was published in Lee's Montana newspapers, October 25, 1968.

62. *Missoulian*, October 9, 1987, 4.

63. *Independent Record*, October 21, 1968, 4.

Chapter 9

64. Truman was fond of telling this story when he gave tours of his presidential library in Independence, Missouri, after he left office.

65. Author's story about the 1968 gubernatorial campaign, *Tribune*, September 1, 1968, 1.

66. Author's interview with McNellis, *Tribune*, October 16, 1968, 1.

67. Author's conversation with Finnegan, *Tribune*, October 16, 1968, 2.

68. Letter from Sullivan to Anderson, August 12, 1968.

69. *Tribune*, October 18, 1968, 1.

70. Babcock's letter to Anderson, October 21, 1968.

71. Anderson's letter to Babcock, October 22, 1968.

72. Author's interview with Patten, *Tribune*, October 16, 1968, 2.

73. UPI "News Analysis" by Bill McFarland, *Billings Gazette*, October 17, 1968, 1.

74. The Montana Poll was released on October 17, 1968. An earlier poll October 3 showed Anderson would get 51 percent of the vote, Babcock 43 percent and Montgomery 6 percent.

75. *Tribune*, September 16, 1968, 1.

76. The tip that Babcock would march to the courthouse came from Patten, Babcock's administrative assistant. Babcock campaigned in Butte on October 18, 1968, after attending a Silver Bow GOP women's club fundraiser the previous night. He also met with Butte anti-vice crusaders when he again promised to send more liquor inspectors to the city.

Chapter 10

77. Author's story about Butte's Urban Renewal program, *Tribune*, *Montana Parade* section, February 22, 1970.

78. Roberts told the author that prostitution was thriving in a motel between Butte City limits and the airport. The girls were picking up customers in nearby bars, Roberts said, and punchboards had returned to some Butte bars. Roberts was right.
79. Anderson appointed Daly to the court on April 6, 1970.
80. Woodahl's staff raided Anaconda on October 14, 1969, swooping into bars at about 6:00 p.m. when people were stopping for a drink on their way home from work. The raid was reported by *The Standard* under a story headlined "Gambling Lid Closed."
81. Author's telephone interview in 2015 with Micone, who lives in Nevada.
82. *Montana Standard*, February 22, 1991, 4. "I think it [the robbery] was the final straw," the sheriff said, explaining why he finally closed the Dumas.
83. *Montana Standard*, March 20, 2012, 1.
84. Author's interview with Woodahl, *Tribune*, April 4, 1969, 2.
85. Author's story, *Tribune*, November 20, 1970, 1.
86. Supreme Court's June 19, 1973 decision in *State Ex Rel, Robert Woodahl & Lawrence Stimatz v. James D. Freebourn.*
87. The Supreme Court's December 4, 1975, four-to-one order in *State v. District Court of Third Judicial District* came after Freebourn appeared so he could argue against Woodahl's request to admit certain exhibits in the bribery trial of Tom Powers. Dissenting associate justice Wesley Castles said he'd like to look at a transcript of the trial proceedings and possibly declare a mistrial.
88. Supreme Court's April 22, 1976 opinion. The court said it was significant that the 1975 legislature, which legalized bingo and keno, refused to enact an amendment to specifically prohibit electronic machine–type keno and bingo.

Chapter 11

89. Author's interview with Woodahl, *Tribune*, April 4, 1969, 4.
90. *Tribune*, September 17, 1971, 1.
91. Woodahl's predecessor as attorney general, Forrest Anderson, also liked to be called "General." Maybe this term of deference comes with the job.
92. McKeon pleaded guilty on May 8, 1974, to four felonies, including stealing a client's money. He was sentenced to two years in prison. He served only about three months in an Idaho prison, where he was sent because as deputy county attorney in Deer Lodge County McKeon

had prosecuted felons serving time in the Montana's state pen, close to Anaconda.

93. The Montana Supreme Court swiftly disbarred McKeon on May 13, 1974, after he pleaded guilty to the worker's comp charges. It reinstated him on December 12, 1982.

94. The Montana Supreme Court censured McKeon on September 2, 1993.

95. Ed Kemmick, a former *Billings Gazette* columnist, wrote in his book, *The Big Sky By and By*, a quite entertaining chapter about Maryona Johnson, who operated the Wild Horse Pavilion bar and bordello with help from her partner, Lyle Cunningham. The chapter was based on a column he wrote for the *Gazette*. Kemmick and *Miles City Star* reporter Amorette Allison said that in later years Johnson was a greeter at the Miles City Walmart.

96. *Independent Record*, May 24, 1968, 1.

Chapter 12

97. Miller's comments about Butte were published in the University of Montana *Montanan* alumni magazine in the spring of 2003. She was married to the late Shag Miller, who owned radio stations in Butte. Her father was Montana author A.B. Guthrie Jr., whose novels include *The Big Sky*.

98. Letter sent to me by Beverly Snodgrass dated November 2, 1968.

99. Bev's house on South Wyoming was later torn down and replaced by a pizza restaurant. By then, Ruby Garrett was operating the Dumas bordello around the corner. Garrett became concerned when crews began trenching for a new sewer line near the poodle's casket. Ellen Crain, who directs the Butte–Silver Bow Public Archives, said that Garrett told her than she made sure the crews stayed away from disturbing the dog's casket.

100. *Tribune*, March 30, 1980, 11.

Chapter 13

101. Told to the author, *Tribune*, October 13, 1968, 1.

102. Bill Freebourn died on July 1, 1970, after he fell into a pool inside the Diamond S. Ranchotel at about 6:30 p.m., his death certificate noted. His body was discovered about twenty minutes later. His obituary two

days later in *The Standard* said that when he died, the attorney was district director of Montana Legal Services, which provided legal assistance to indigent clients. The weekly *Boulder Monitor* never mentioned Bill's death.

103. The BAC (blood alcohol content) level for driving intoxicated was 0.10 percent in 1970. The legislature adopted a stricter standard of 0.08 percent in 2003.

104. Details of the court settlement are on file in the Butte–Silver Bow Clerk of the District Court's office.

105. Beverly Snodgrass's obituary was published on October 6, 1987, in *The Standard*. By then, her two brothels had been razed, and with the closing of the Dumas, the city no longer had a house of prostitution.

106. No one the author talked to knew anything about the New Silver Bow Zoo. Bev's obituary said that donations for the zoo could be sent to 305 West Mercury Street, an address on the same street where the madam operated her last brothel. Perhaps the former madam's relatives were just being playful for including this in her obituary, as when Bev died, this was the address of the Butte Local Development Corporation.

107. Freebourn died on December 28, 1998, in a Butte nursing facility.

108. Foote's column about Freebourn was published in the *Butte Weekly*, January 6, 1999, 4.

109. *Montana Standard*, December 29, 1988, 1 and obituary page.

110. John C. Harrison barely won the high court with 118,635 votes to Freebourn's 116,981.

111. Freebourn's last day on the bench was September 31, 1980.

112. *Montana Standard*, April 22, 1978, 1. The headline read, "Winston Charges Freebourn with Bias."

113. Dzivi complained about Freebourn during a hearing before the Montana Supreme Court on December 5, 1975. The hearing was to determine whether to remove Freebourn from presiding over the bribery case against former Butte mayor Tom Powers after the judge had dismissed the charges. The high court voted four to one not to remove Freebourn.

Epilogue

114. Told to me by Dolores Arnold when I interviewed her in October 1973 in Wallace after she had been forced to close her two houses of prostitution.

115. This happened to the author's car whenever he spent the night in Kellogg.

116 The figures came from the Bunker Hill Company.

117. Based on the author's observations over a period of five years on how state liquor laws were largely ignored in the Coeur d' Alene Mining District.

118. Brainard said he would have been criticized if his newspaper had written about closing the brothels in nearby Wallace, but it was okay to print a story written by someone else. The *Kellogg Evening News* didn't have an editorial page. Publisher Bill Penney said that editorials just stirred up his readers. "It's a lot better for us to write about the great things happening in our schools," Penney said. Penney picked a strange place to live, as he was battling emphysema. He always kept a spare tank of oxygen in the trunk of his Cadillac.

119. *Evening News*, October 9, 1973.

FURTHER READING

A large portion of the material in this work is from the author's interviews and reporting, along with original sources, including court records and opinions, affidavits, official election results, private letters, deeds, inquest reports, journals of the Montana legislature, 1899 Montana Constitutional Convention proceedings and newspapers. There are hundreds, most likely thousands, of books written about Butte. I'm not alone in believing that the best of them is the novel *Mile High Mile Deep* by Richard O'Malley. The 2007 collectors' edition by Clark City Press has a painting of a Butte headframe by Russell Chatham. "It is fiction, though like many first novels it is largely autobiographical," O'Malley's daughter, Sidney Armstrong, told me. She said that many of the events did happen and that some of the Butte "characters" are real. To learn about the hard life of the Butte working girl and the prostitution industry, you can't go wrong reading articles by Ellen Baumler, the Montana Historical Society's interpretive historian.

Copies of the actual pages of the *Tribune*'s series about Butte vice, published October 13–20, 1968, may be viewed online or in the files of the Montana Historical Society in Helena and Butte–Silver Bow Public Archives. The series inspired this book, but most of the material is new or updated.

Newspapers, some dating back to the early 1900s, are quoted by the author in this work. They include the *Butte Miner*, *The Montana Standard-Butte Daily Post*, *The Montana Standard*, the *Missoulian*, the Helena *Independent Record*, the *Billings Gazette*, the *Butte Weekly* and the *Kellogg (ID) Evening News*.

Babcock, Tim, and Betty Babcock, with Linda Grosskopf. *Challenges Above and Beyond*. N.p.: Special Projects, 2008.

Bossard, Floyd. *The Richest Hill on Earth*. Butte, MT: Wordz and Ink, 2012.

Botkin, Jane Little. *Frank Little and the IWW: The Blood that Stained an American Family*. Norman: University of Oklahoma Press, 2017.

Butte's Red Light District: A Walking Tour. Montana Historical Society, undated.

Crain, Ellen, and Lee Whitney. *Images of America: Butte*. Charleston, SC: Arcadia Publishing, 2009.

Davenport, William. *Butte and Montana Beneath the X-ray*: N.p.: X-Ray Publishing Company, 1908. For something really weird, read this one. The book mainly pokes fun at Butte's upper class and is based on articles written by Davenport, who claimed a large readership in the red-light district. You can find it in archives and online.

DeVoto, Bernard, ed. *Mark Twain in Eruption*. New York: Harper, 1940.

Drumullon Views. "The End of the Line: Butte, Anaconda and the Landscape of Prostitution" (Spring 2009).

Emmons, David. *Butte Irish: Class and Ethnicity in an American Town*. Champaign: University of Illinois Press, 1989. After reading this, no one can doubt that the Irish ran Butte, from The Anaconda Company to the courthouse.

Gibson, Richard. *Lost Butte*. Charleston, SC: The History Press, 2012. What the wrecking ball did to Uptown Butte.

Glasscock, C.B. *War of the Copper Kings*. Helena, MT: Riverbend Press, 2002.

Hammett, Dashiell. *Red Harvest*. New York: Knopf, 1929. In a class by itself. Hammett spent time in Butte helping Anaconda Copper Company as a Pinkerton detective. The book depicts the fictional town of Personville, which is obviously Butte. In the book, the locals call it "Poisonville."

Howard, Joseph Kingsley. *Montana: High, Wide and Handsome*. With introductions by William Kitteridge and A.B. Guthrie Jr. Lincoln, NE: Bison Books, 2003.

Kearney, Pat. *Butte's Pride: The Columbia Gardens*. Butte, MT: Sky High Communications, 1994. Copper King W.A. Clark built this glittering amusement park for his workers and the people of Butte. It featured numerous rides, including a roller coaster and a large dance pavilion. It closed in 1973 and was heavily damaged by fire the same year. What was left has gradually disappeared into the expanding Continental Pit.

Lynde, Stan. *To Kill a Copper King*. Bloomington, IN: iUniverse Inc., 2010. Lynde, Montana's most famous cartoonist, created the *Hipshot* and *Rick O'Shay* comic strips.

Malone, Michael. *The Battle for Butte.* Seattle: University of Washington Press, 2006.

McGlashan, Zena Beth. *Buried in Butte.* Butte, MT: Wordz and Ink, 2015.

Montana Standard. "Mining City Memories: The Early Years." 2016. Butte photos from the late 1880s through 1939.

Montana: The Magazine of Western History. "Devil's Perch: Prostitution from Suite to Cellar in Butte, Montana" (Autumn 1988).

Peirce, Neil R. *The Mountain States of America: People, Politics and Power in the Eight Rocky Mountain States.* New York: W.W. Norton Company, 1972.

Proceedings and Debates of the Montana Constitutional Convention, 1889. Helena, MT: State Publishing Company, 1921.

Punke, Michael. *Fire and Brimstone: The North Hill Mining Disaster of 1917.* New York: Hyperion, 2006.

Swibold, Dennis. *Copper Chorus: Mining, Politics and the Montana Press, 1889–1959.* Helena: Montana Historical Society, 2006.

Vincent, Matt, and Chad Okrusch. *Butte: The Richest Hill on Earth.* Charleston, SC: Arcadia Publishing, 2012.

Wolle, Muriel Sibell. *Montana Pay Dirt: A Guide to the Mining Camps of the Treasure State.* N.p.: Sage Press, 1963. The original sketches of mining camps, including Butte, make this book unique.

Workers of the Writer's Program. *Copper Camp: Stories of the World's Greatest Mining Town.* New ed. Helena, MT: Riverbend Publications, 1976.

INDEX

ABOUT THE AUTHOR

Photo by Tom Kuglin.

John Kuglin was born in Chicago and received a BA in history from the Colorado College. He began his long career as a journalist before graduation as a reporter for the *Colorado Springs Free Press*. Later, he was a city hall reporter for the rival *Gazette-Telegraph*. Kuglin moved in 1965 to Montana, where he was a copy editor and reporter for the *Missoulian* and *Independent Record*. He was a statehouse reporter for the *Great Falls Tribune* and covered the 1972 Montana Constitutional Convention. He worked thirty-one years for the Associated Press in Spokane, Washington; Cheyenne, Wyoming; and Helena. He retired in 2005 as AP's bureau chief for Montana and Wyoming. Kuglin helped launch the Montana Freedom of Information Hotline, which he chaired for eighteen years. It provides free legal advice to citizens denied the right of access to public meetings, records and the courts. He was the first recipient of the Montana Free Press Award from the schools of law and journalism at the University of Montana, received the Jeannette Rankin Civil Liberties Award "for fighting for Montanans' right to know" and was inducted into the Open Government Hall of Fame by the National Freedom of Information Coalition and Society of Professional Journalists. Kuglin lives in Helena with his wife, Gale.